Sublime Beauty

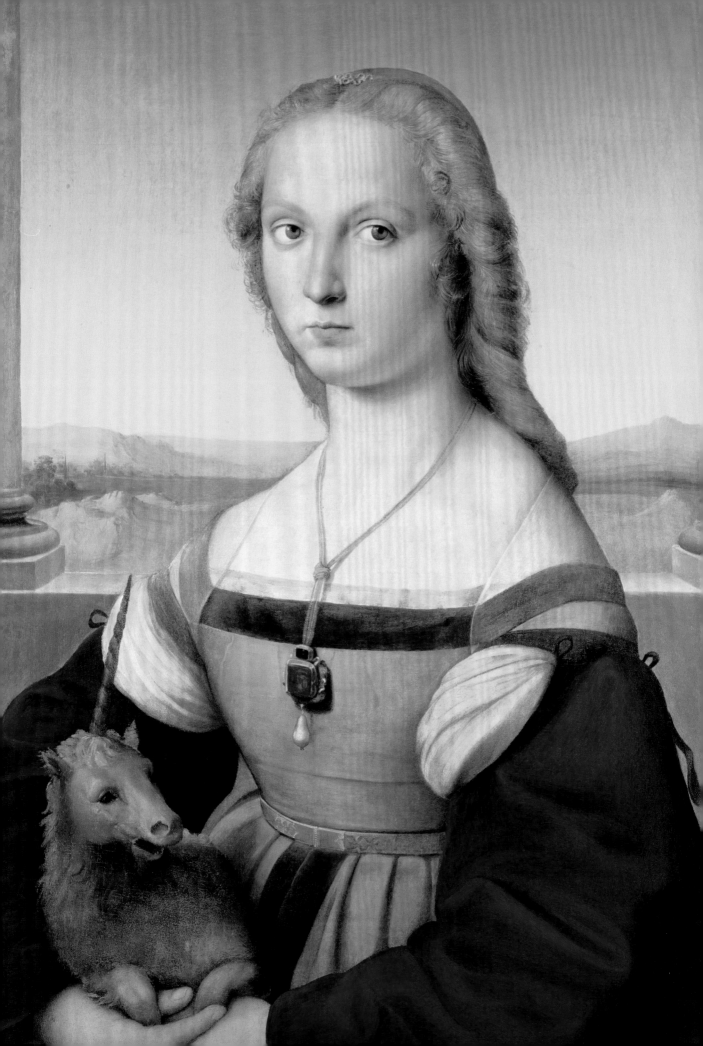

Sublime Beauty

Raphael's

Portrait of a Lady with a Unicorn

Edited by Esther Bell

with contributions by Linda Wolk-Simon, Mary Shay-Millea,
and Anna Coliva

Cincinnati Art Museum
in association with
D Giles Limited, London

GALLERIA · BORGHESE

FIAC
FOUNDATION
FOR ITALIAN
ART & CULTURE

cincinnati ✱ art museum

Fine Arts Museums of San Francisco

This catalogue accompanies the exhibition *Sublime Beauty: Raphael's* Portrait of a Lady with a Unicorn on display at Cincinnati Art Museum from October 3, 2015 – January 3, 2016 and at the Legion of Honor, Fine Arts Museums of San Francisco from January 9 – April 10, 2016.

The exhibition was organized by the Cincinnati Art Museum and the Fine Arts Museums of San Francisco in collaboration with the Foundation for Italian Art and Culture, the Galleria Borghese, and the Ministero dei Beni e delle Attività Culturali e del Turismo.

The Cincinnati Art Museum expresses gratitude for the support provided by ArtsWave, the Ohio Art Council, the City of Cincinnati, as well as our members.

This presentation at the Legion of Honor is made possible by a lead sponsorship from the Frances K. and Charles D. Field Foundation, in memory of Mr. and Mrs. Charles D. Field.

First published jointly in 2015 by GILES
An imprint of D Giles Limited
4 Crescent Stables
139 Upper Richmond Road
London SW15 2TN
UK
www.gilesltd.com

ISBN: 978-1-907804-73-1

The exhibition was organized by Esther Bell, Curator in Charge of European Paintings at the Fine Arts Museums of San Francisco and formerly Curator of European Paintings, Drawings, and Sculpture at the Cincinnati Art Museum

For the Cincinnati Art Museum:
Esther Bell, Editor
Anne Buening, Managing Editor
Connie Newman, Retail Coordinator

For D Giles Limited:
Copy-edited and proof-read by Jodi Simpson
Designed by Caroline and Roger Hillier, The Old Chapel Graphic Design
Produced by GILES, an imprint of D Giles Limited, London
Printed and bound in Hong Kong
All measurements are in inches and centimeters; Height precedes width precedes depth.

Front cover and frontispiece:
Raphael, *Portrait of a Lady with a Unicorn* (detail), ca. 1505–6, oil on canvas transferred from panel, Galleria Borghese, Rome, inv. 371

Back cover:
Raphael, *Portrait of a Lady with a Unicorn*, ca. 1505–6, oil on canvas transferred from panel, Galleria Borghese, Rome, inv. 371

Contents

Forewords 6

Acknowledgments 8

Laura in a Loggia 11
Raphael's *Portrait of a Lady with a Unicorn*
LINDA WOLK-SIMON

The Lover Entrapped 33
Virtue and Vice in Raphael's *Portrait of a Lady with a Unicorn*
MARY SHAY-MILLEA

Portrait of a Lady with a Unicorn 47
Plates
Provenance and Conservation History

Notes 51

Bibliography 58

Photography Credits 62

Index 63

Supplement 65
Lady with a Unicorn
A Bridal Portrait
ANNA COLIVA

Forewords

In 1830, Eugène Delacroix, who himself had rejected the classicizing forms of the Renaissance, pronounced: "The sublimity of his talent, combined with the special circumstances in which he lived . . . have raised [Raphael] on a throne from which no one has replaced him."[1] Delacroix, like a panoply of artists before and after him, acknowledged the significance of Raphael in the history of western art.

Born in 1483, Raffaello Sanzio da Urbino, known as Raphael, along with Leonardo da Vinci and Michelangelo, is synonymous with the High Renaissance. In his active studio, Raphael produced many of the most celebrated works of the sixteenth century, including iconic paintings, altarpieces, drawings, and tapestry cartoons. Among his most distinctive efforts is his masterpiece *Portrait of a Lady with a Unicorn*, which entered the Borghese collection from the estate of Olimpia Aldobrandini upon her marriage to Paolo Borghese in 1640. Long unattributed in the Borghese inventory, the painting was not properly recognized as one of Raphael's achievements until the early twentieth century.

In the persuasive essays that follow, the authors offer innovative analyses of this remarkable work. Linda Wolk-Simon uses visual references and archival clues to identify convincingly the sitter in question as Laura Orsini della Rovere (b. 1492), daughter of the celebrated beauty Giulia Farnese (1474–1524). Wolk-Simon proposes that the portrait was created upon the occasion of Laura's marriage. To support her argument, the author explains Raphael's inclusion of the unicorn as a symbol of chastity and virtue. She concludes by drawing parallels between the painting and the poet Petrarch's muse, also named Laura. The essay that follows by Mary Shay-Millea expands this discussion about the painting's associations with Petrarchan love poetry and the aristocratic Renaissance practice of exchanging portraits to advertise a bride's most appealing features. Director of the Galleria Borghese, Anna Coliva, proposes an alternative hypothesis about the painting and its creation.

Not previously exhibited in the United States, this depiction of a blonde-haired beauty is certain to capture public attention in both Cincinnati and San Francisco. With her subtle side-glancing gaze, her porcelain skin, and, of course, the mysterious unicorn sitting on her lap, Raphael's lady justifies the lofty reputation the artist has held over the centuries.

Esther Bell, Curator in Charge of European Paintings
Fine Arts Museums of San Francisco

1 Eugène Delacroix, "Essai sur les artistes célèbres: Raphael," *Revue de Paris* XI (1830): 142.

The Foundation for Italian Art & Culture (FIAC) is honored to partner with the Cincinnati Art Museum and to collaborate, once again, with the Fine Arts Museums of San Francisco on the foremost arrival to the United States of the Renaissance masterpiece, Raphael's *Portrait of a Lady with a Unicorn*, from the Galleria Borghese in Rome. A unique portrayal of a youthful beauty sitting with her symbolic companion, Raphael's masterpiece will surely captivate viewers in Cincinnati, Ohio, and in San Francisco, California.

The painting's historical visit to the Cincinnati Art Museum marks a significant achievement for FIAC, as it exemplifies our mission to promote the highest quality Italian art throughout the United States. Furthermore, this remarkable presentation debuts just one year after the equally noteworthy exhibition of Parmigianino's *Schiava Turca*, from Parma, at the Fine Arts Museums of San Francisco.

Along with our distinguished Board Members, we wish to express our sincere appreciation to Cameron Kitchin, Louis and Louise Dieterle Nippert Director of the Cincinnati Art Museum, with whom we are so pleased to collaborate, and to Dr. Colin B. Bailey, former Director of the Fine Arts Museums of San Francisco, for his steady support. We extend our deepest thanks to Dr. Esther Bell, Curator in Charge of European Paintings at the Fine Arts Museums of San Francisco and former Curator of European Paintings, Drawings, and Sculpture at the Cincinnati Art Museum, for her trust and perseverance in seeing this project through. Anna Coliva, Director of the Galleria Borghese, and Marina Minozzi are due a special debt of gratitude. Additional thanks are due to Dario Franceschini, Ugo Soragni, and especially Arch. Antonia Pasqua Recchia, Secretary General, Ministry of Italian Culture. At the Superintendent of the Museums of Rome's offices, Dott.ssa Daniela Porro and her staff have our deepest gratitude for making this extraordinary loan possible.

Daniele D. Bodini, Chairman
Alain Elkann, President
Foundation for Italian Art & Culture

Acknowledgments

Working together to bring Raphael's masterpiece *Portrait of a Lady with a Unicorn* (1505–6) to the United States for the first time has been an exciting opportunity for our respective museums. We especially thank Anna Coliva, Director of the Galleria Borghese, for her gracious support of this project. This special presentation was organized in collaboration with the Foundation for Italian Art & Culture; thanks go to Ambassador Daniele D. Bodini, Chairman, and Alain Elkann, President, for their help in facilitating the project. We are grateful for the steadfast assistance of their Executive Director, Olivia D'Aponte. We owe an enormous debt of thanks to the Galleria Borghese for generously lending one of Italy's greatest treasures to Cincinnati and San Francisco. Also, in Rome, Daniela Porro, Soprintendenza Speciale per il Patrimonio Storico, Artistico, ed Etnoantropologico e per il Polo Museale della città di Roma, and her colleagues including Giulia Macaluso and Aurelio Urciuoli were essential throughout the project from its inception through to the collegial exchange. The Cincinnati Art Museum gratefully acknowledges the operating support generously provided by ArtsWave, the Ohio Arts Council, and the City of Cincinnati, as well as our members. The presentation at the Legion of Honor is made possible by a lead sponsorship from the Frances K. and Charles D. Field Foundation, in memory of Mr. and Mrs. Charles D. Field, for which the Fine Arts Museums are most appreciative.

We acknowledge our respective staffs for their hard work and collegiality. Special thanks are given to Esther Bell, who conceived of this focus exhibition when Curator of European Paintings, Drawings, and Sculpture at the Cincinnati Art Museum; she will now oversee it as Curator in Charge of European Paintings at the Fine Arts Museums of San Francisco. Others at the Cincinnati Art Museum who deserve special mention are Anne Buening, Research Assistant, for her organizational skills, as well as Cynthia Amnéus, Jennifer Eckman, A.J. Gianopoulos, Jennifer Hardin, Susan Hudson, Galina Lewandowicz, and Kirby Newman. At the Fine Arts Museums, we acknowledge Colin B. Bailey, Emerson Bowyer, Krista Brugnara, Melissa Buron, Therese Chen, Elise Effmann Clifford, Julian Cox, Leslie Dutcher, Michele Gutierrez-Canepa, Patty Lacson, Daniel Meza, Lisa Podos, and Sheila Pressley.

Cameron Kitchin, Louis and Louise Dieterle Nippert Director
Cincinnati Art Museum

Richard Benefield, Deputy Director of Museums and Chief Operating Officer
Fine Arts Museums of San Francisco

Jacopo del Sellaio
Triumph of Chastity
(detail)
ca. 1480–85

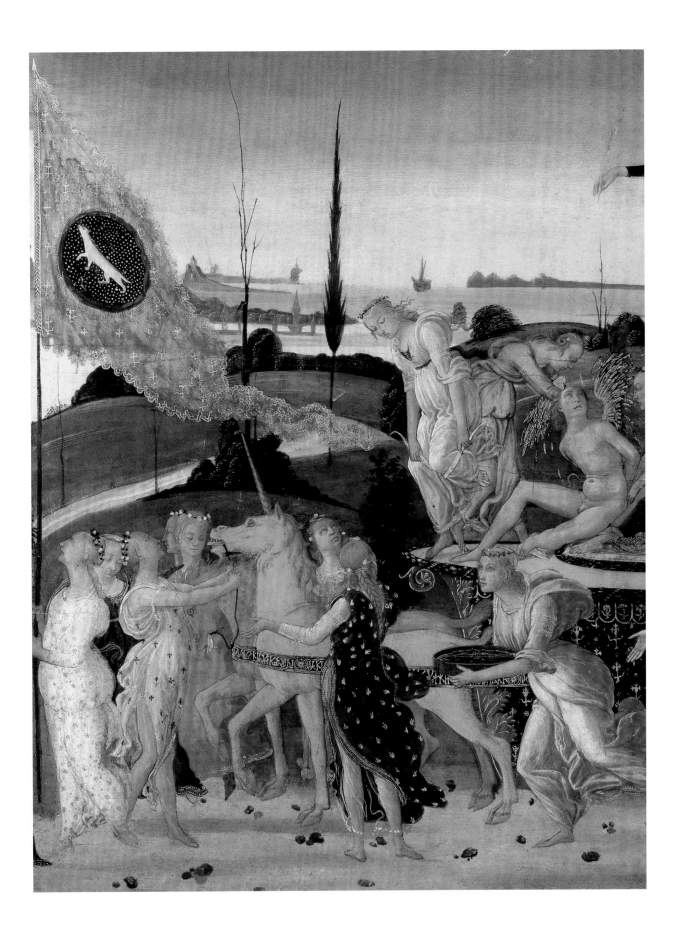

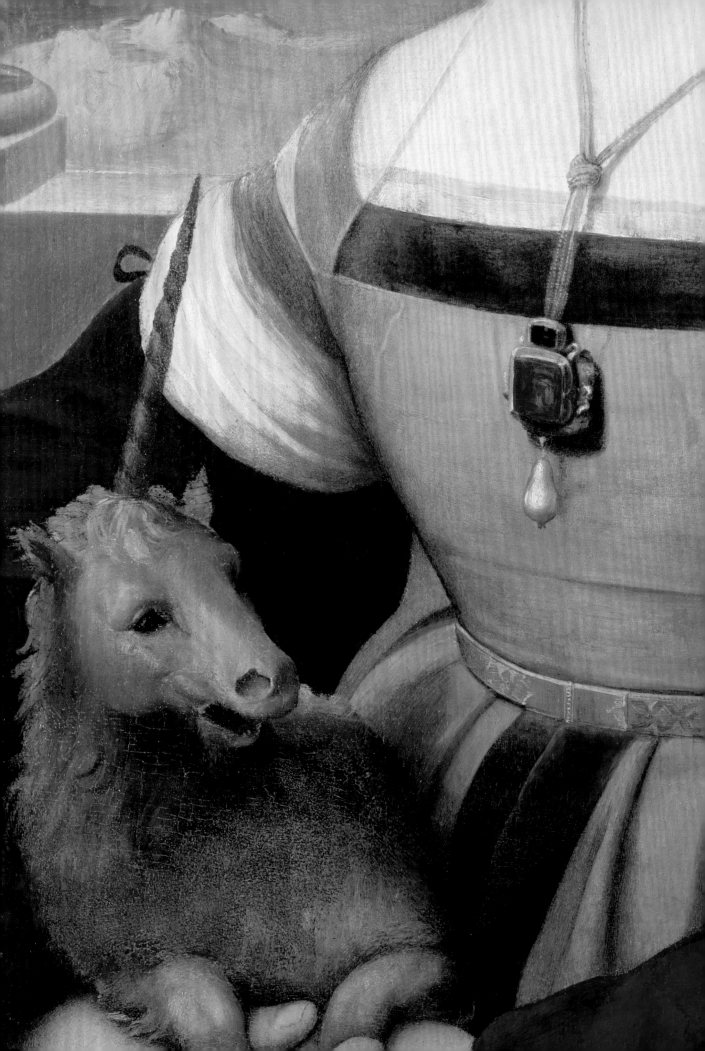

Laura in a Loggia

Raphael's *Portrait of a Lady with a Unicorn*

LINDA WOLK-SIMON

Raphael's captivating portrait of a young woman with a unicorn (pl. 1, p. 46) is an enigma. When and where was it painted? What occasioned the commission? Why, in a revision to the original design, does the sitter hold a unicorn? And, most obviously, who does it represent? About these fundamental questions contemporary sources are frustratingly silent. There is no record of payment for the picture, no contractual or epistolary exchange between the painter and a patron that might shed light on the circumstances of its genesis, and no reference to the portrait in early written sources dealing with Raphael's life and career. Giorgio Vasari, in *Le vite de' più eccellenti pittori, scultori ed architettori* (*Lives of the Most Excellent Painters, Sculptors, and Architects*), first published in 1550, offered a rich and deeply informed chronicle of the artist's activity—one that was penned within a few decades of Raphael's premature death in 1520—yet this portrait goes unremarked. Perhaps Vasari had never seen the work. Or perhaps he neglected to mention it because he did not consider it to be by Raphael—an attribution that was only proposed in the early twentieth century (though not to universal agreement), hence the portrait's omission from the earlier literature and relatively scant bibliography.[1]

Oblivion attached to the picture early in its history. In an inventory drawn up in 1682 it is laconically described as "a painting on panel with a woman seated with a unicorn in her arms, about one and one half *palmi* high, in a black frame, artist uncertain (*mano incerta*)."[2] Thus, already in the century after it was painted, its then-owners had little comprehension of this particular treasure in their possession, regarding it generically as a portrait of an unknown sitter by an unknown artist. Those owners were the Borghese, a princely family whose recent ascendancy in Rome was owing to the elevation to the papacy in 1605 of

Raphael
Portrait of a Lady with a Unicorn (detail)
ca. 1505–6

Camillo Borghese (Pope Paul V, reg. 1605–21). In 1638 his grand-nephew Paolo Borghese wed Olimpia Aldobrandini (1623–81), daughter of another princely family whose own preeminence likewise derived from the exceeding good fortune that had recently placed an illustrious relation on the papal throne (Clement VIII Aldobrandini, reg. 1592–1605). Through marriage alliances, the Aldobrandini were linked not only to the Borghese, but also to the more venerable Pamphili and, since 1600, to the Farnese. Though most of the extraordinary collection of paintings inherited by Olimpia Aldobrandini passed to the offspring of her second marriage to Camillo Pamphili, *Portrait of a Lady with a Unicorn* was among the works that remained with her Borghese descendants. Those later generations were no more knowledgeable about their portrait. The eventual metamorphosis of the sitter into Saint Catherine of Alexandria—effected in the later seventeenth century by the addition of an ample cloak and martyr's palm and the replacement of the unicorn with a broken wheel, the saint's attribute (pl. 2, p. 48)[3]—confirms that whatever biography originally accompanied her had long been forgotten.

Recent scholarship has established that the portrait was in the Aldobrandini collection by 1623.[4] That pedigree—the earliest piece of information that has emerged from the painting's obscure early history—may harbor a clue about the identity of the sitter. Others reside in the image itself—the specifics of the woman's features, costume, attributes, and physical setting—and in its presumed date. The following discussion will uncover and assemble this scant evidence and, on its basis, venture a hypothesis about the identity of the unknown lady with a unicorn.

• • • • •

The Borghese portrait is undated, but there is widespread agreement among scholars that it was executed around 1505–6.[5] In that period Raphael was resident principally in Florence. He had arrived in 1504, reportedly bearing a letter of introduction from Giovanna Feltria della Rovere, sister of the Duke of Urbino, commending him as a "sensible and well-mannered young man" who was determined to "spend some time in Florence to study."[6] Although he was based there until moving permanently to Rome in 1508, these were in fact peripatetic years for Raphael: between 1504 and 1507 he is documented twice in Perugia and no fewer than four times in his native Urbino; there is reason to believe that he may have made a trip to Rome in these years as well.[7] Not all the works executed during the chronological span that is designated Raphael's Florentine period, then, were produced for Florentine patrons or even necessarily painted in Florence. The *Small Cowper Madonna* of about 1505 (fig. 1), for instance, includes a localized topographical detail—the church of San Bernardino, outside the walls of Urbino—

Fig. 1
Raphael (1483–1520)
Small Cowper Madonna
ca. 1505
oil on panel
23⁷/₁₆ × 17⁵/₁₆ in.
(59.5 × 44 cm)
National Gallery of Art,
Washington, DC
Widener Collection
1942.9.57

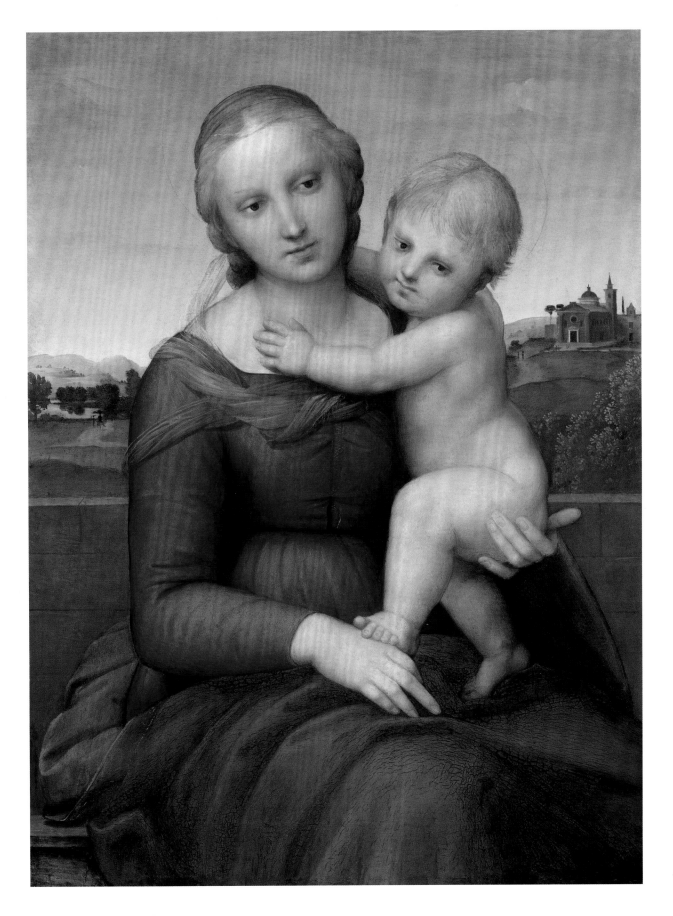

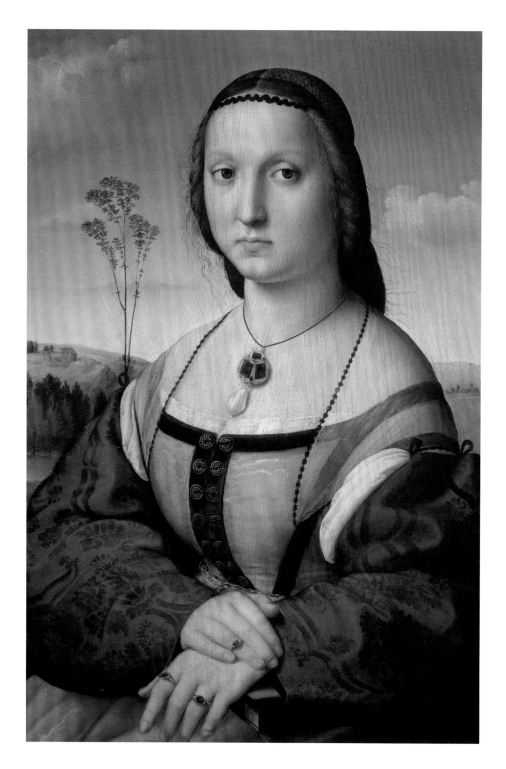

which indicates that the unrecorded patron was not Florentine, but rather hailed
from the city of Raphael's birth.[8] A similar scenario might pertain to the *Portrait
of a Lady with a Unicorn* (which, interestingly, shares the compositional motif of a
parapet separating foreground figure from distant background, a pictorial device
unique to these two works).

The Borghese portrait relates closely in pose, composition, and the
volumetric treatment of forms to Raphael's portrait of the Florentine patrician

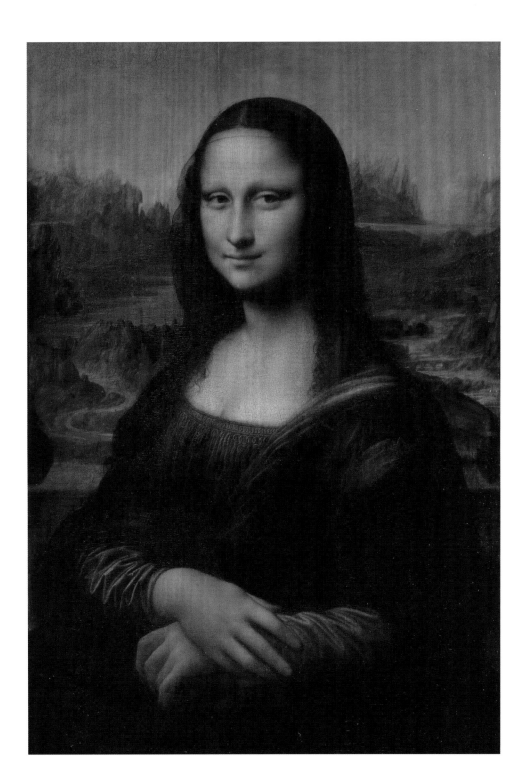

Fig. 3
Leonardo da Vinci
(1452–1519)
Mona Lisa
1503–6
oil on wood
30⁵/₁₆ × 20⁷/₈ in.
(77 × 53 cm)
Musée du Louvre, Paris
inv. 779

Maddalena Strozzi (fig. 2), which is generally thought to have been executed in 1505–6. (The resemblances are such that the *Lady with a Unicorn* was once erroneously believed to be the pendant to the portrait of Maddalena's husband, Agnolo Doni, and hence to depict Maddalena Strozzi herself; the subject of the actual portrait of Maddalena was in turn improbably identified as her own mother-in-law.[9]) Both portraits are indebted to the *Mona Lisa* (fig. 3), one of the works by Leonardo da Vinci that profoundly influenced the younger artist

during his years in Florence. Raphael not only adopted the format of the half-length seated figure with hands crossed in her lap, angled slightly away from the picture plane and set before a distant landscape, he also endowed both sitters with a compelling physical presence. The ambiguous setting of Leonardo's portrait was at some stage of its genesis interpreted as an open loggia, as a nearly contemporary copy makes clear.[10] This compositional device recurs in the *Portrait of a Lady with a Unicorn*.

Relevant here is a masterful pen-and-ink drawing by Raphael of a young woman seated in a loggia that opens onto a distant landscape (pl. 4).[11] Datable, like the Borghese portrait, to 1505–6, it has been variously connected with the *Maddalena Strozzi* and the *Portrait of a Lady with a Unicorn*, and has also been regarded as a rumination on the *Mona Lisa*—an artistic exercise in a Leonardesque idiom rather than a preparatory study for a specific painting.[12] Numerous resemblances to the Borghese portrait include the sitter's pose, hairstyle, and voluminous left sleeve, and her placement between two framing columns that rise from the shoulder-height wall behind her. These affinities support the contention that the drawing is a preparatory study for the painting, even if it is not immediately obvious that both portray the same subject.

The drawing's ambiguity derives from its paradoxical adherence to the mimetic properties of portraiture in the meticulously observed details of the woman's costume, headdress, and setting, and its departure from those same conventions in her prettified, vaguely veiled features: the physiognomy (a signal province of portraiture) is idealized and formulaic rather than descriptive and specific, and does not persuade as an actual likeness. This inherent contradiction can be reconciled if the drawing portrays a sitter who was not physically present and whose actual appearance was therefore unknown to the artist.[13] Although the painted portrait moves in the direction of a more particularized portrayal, the striking blonde hair (which distinguishes this unknown woman from the sitters in virtually all of Raphael's other portraits[14]) and blue eyes, and the regularized features, still suggest a certain license.[15] In both the painting and the drawing it may be that the specifics lie not in the sitter's pleasing but oddly nondescript physical appearance, but in the setting and the landscape background, external attributes that were meant to signal a specific locus and, by extension, some ties to that place.

It has not been previously observed that the cluster of buildings in the right background of the portrait drawing, which includes a tall, conical campanile with a distinctive tapering spire, appears to represent San Francesco in Urbino (fig. 4).[16] Erected in the early fourteenth century, the church is one of the principal

Plate 4
Raphael
*Portrait of a Young
Woman* (detail)
ca. 1505–6

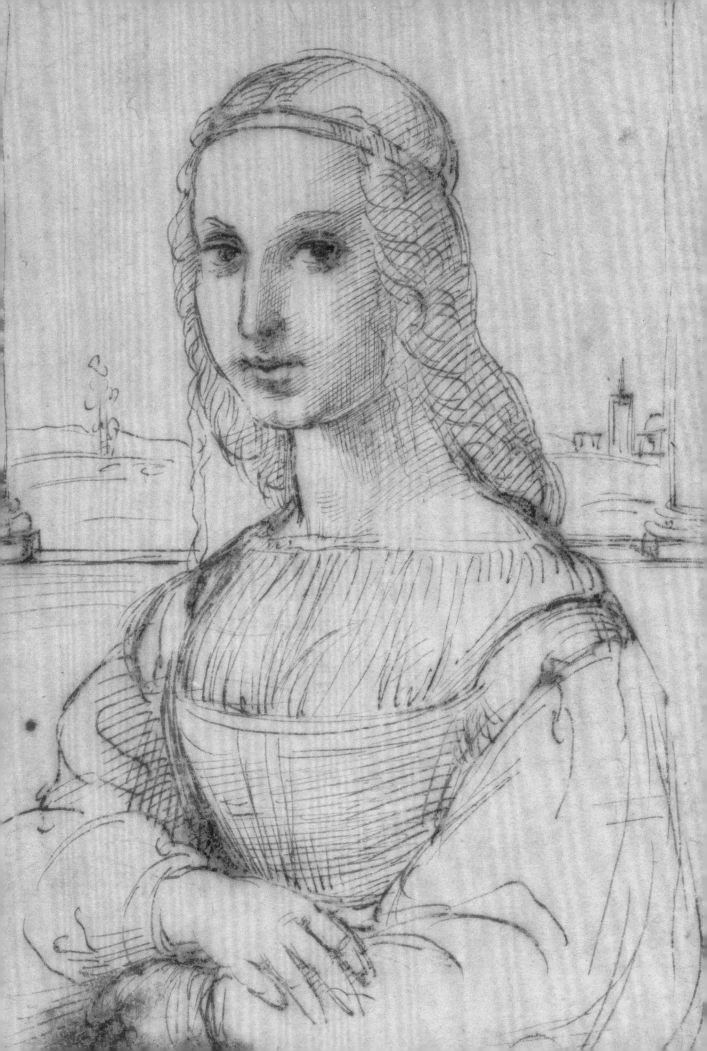

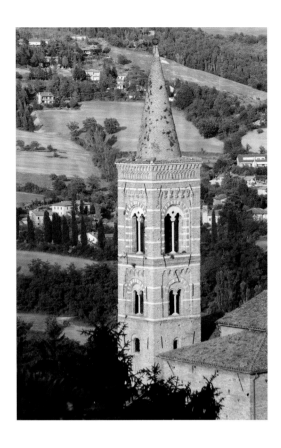

Fig. 4
Church of San Francesco,
Urbino, campanile

Fig. 5
Raphael
Small Cowper Madonna
(detail)
ca. 1505

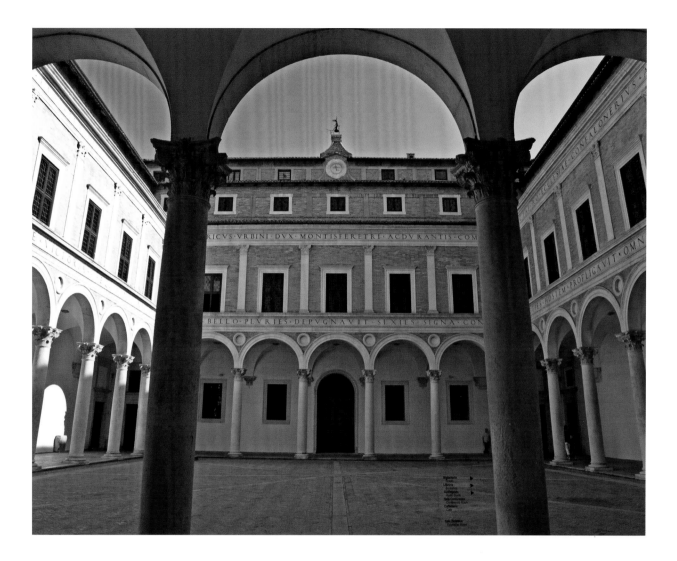

Fig. 6
Luciano Laurana
(ca. 1420–1475),
architect, Courtyard of
the Palazzo Ducale,
Urbino, built 1472

ecclesiastical foundations of the city and a pantheon housing the tombs of some of its most celebrated citizens, among them the painters Federico Barocci, Timoteo Viti, and Raphael's father, Giovanni Santi. This localized architectural detail—like the comparable, site-specific church of San Bernardino in the background of the *Small Cowper Madonna* (fig. 5)—signals some connection of the presumed project to which this drawing relates with Urbino.[17] Certain of Raphael's contemporaries may have discerned a further allusion to that locus in the columns flanking the seated woman in the portrait drawing: to a patron or compatriot from Urbino this detail must have registered as a suggestive evocation of the graceful arcades, colonnades, and balconies of the Palazzo Ducale (fig. 6). Those connotations carry over to the painted portrait of the lady with a unicorn, in which this framing device, and the entire compositional scheme, are retained

(the prominent campanile at the right having been recast as a slender, diminutive tower barely visible in the distant left background [fig. 7]).

These visual references suggest that Raphael's *Portrait of a Lady with a Unicorn*, while produced during his Florentine period and adhering to a new, Leonardesque idiom of female portraiture, was commissioned by a patron connected to Urbino rather than Florence, probably during one of the artist's documented visits there in the years in question (when he would have had occasion to draw not just from memory, but *dal vero*, the campanile and surrounding structures of San Francesco seen in the background of the portrait drawing). The essential question of the unknown sitter's identity persists, however, and with a more specific inflection: Was there a young woman with some connection to Urbino—resident or not— whose portrait Raphael would have had occasion to paint around the years 1505 or 1506, and for whom a dog (the animal the sitter originally held, based on X-rays) and/or a unicorn would have been an appropriate symbol? There is one compelling candidate whose biography—and, conceivably, whose appearance, to the extent it may be conjectured—accords neatly with the chronology and circumstances posited for the *Portrait of a Lady with a Unicorn*: Laura Orsini della Rovere (b. 1492).

Laura Orsini was the daughter of the celebrated beauty Giulia Farnese (1474– 1524), sister of Cardinal Alessandro Farnese (the future Pope Paul III, reg. 1534–48) and mistress of the notoriously worldly and nepotistic Borgia Pope Alexander VI (reg. 1492–1503).[18] Few at the time doubted that Laura's true father was the pope himself, newly elevated to the throne of Saint Peter in the year of her birth, rather than Giulia's inconsequential husband, Orsino Orsini[19]—a persistent rumor supported by contemporary accounts and given voice by various chroniclers.[20] Among them was Vasari, who reported that in the Borgia apartments in the Vatican Pinturicchio painted an image of Alexander VI adoring the Madonna and Child, in which "the features of Our Lady" were those of "Signora Giulia Farnese" (and the child's, by implication, those of the infant Laura)—a most indecorous, even blasphemous family portrait in the eyes of later inhabitants of the papal palace, who concealed the image behind a curtain and eventually had it removed.[21] If this was indeed Laura's parentage, Alexander's children from an earlier liaison, including the infamous Cesare and Lucrezia Borgia, were her half-siblings. Were they blood relations, some inkling of Laura's appearance is perhaps to be gleaned from portraits of Lucrezia. Given the uncertain status and dubious veracity of the few known images that purport to portray Lucrezia Borgia, little meaningful can be inferred.[22] It does seem certain, however, that, like the woman in Raphael's portrait, Lucrezia had blonde hair—in that day, unusual in Italy.[23] Contemporary

Fig. 7
Raphael
Portrait of a Lady with a Unicorn (detail)
ca. 1505–6

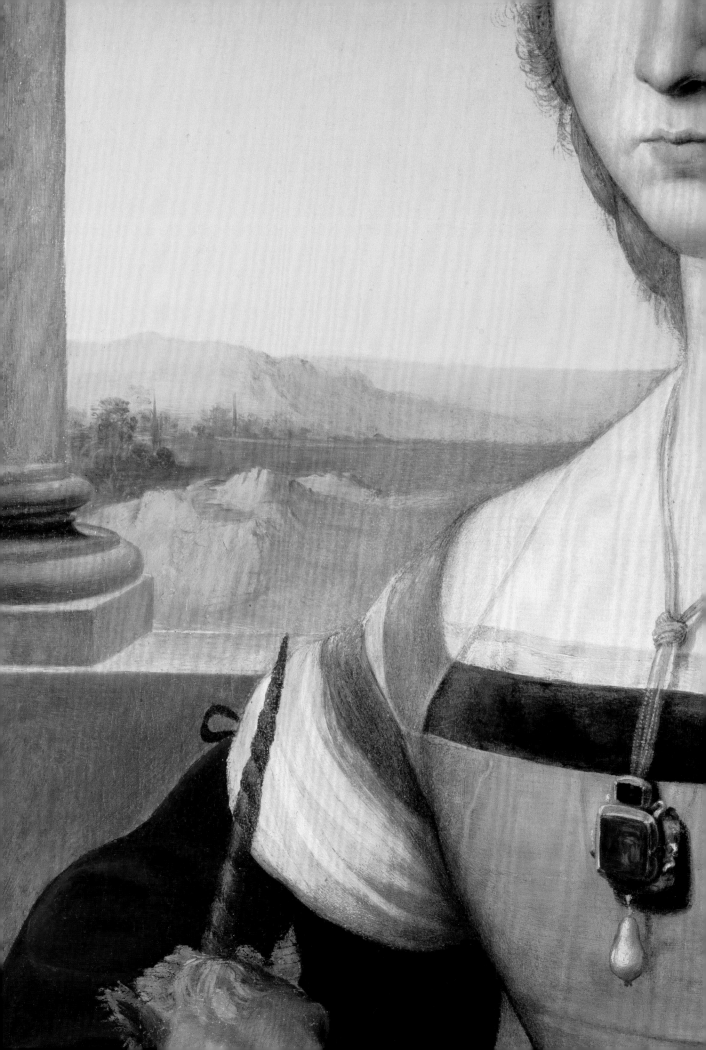

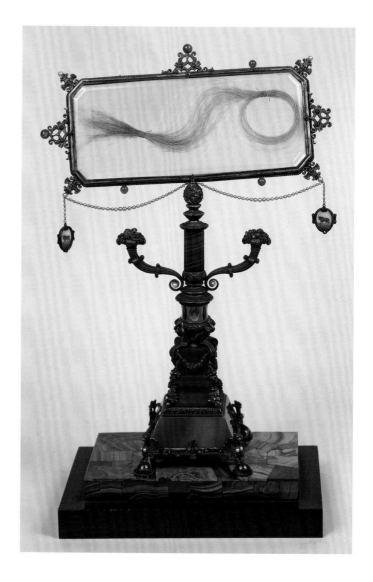

descriptions of Lucrezia extol her stunning golden tresses,[24] and tradition holds that a lock of blonde hair preserved in a reliquary in the Biblioteca Ambrosiana in Milan is hers—a token cherished by her impassioned but platonic lover, the poet Pietro Bembo (fig. 8).[25] Half-siblings or not, Lucrezia Borgia and the young Laura Orsini lived together for a time in Rome with Laura's mother, Giulia Farnese, in the palace of the pope's cousin, Adriana de Mila (Giulia's stepmother-in law), adjacent to the Vatican and most conveniently situated for impromptu papal visits, both conjugal and paternal. It was a genial, if most unconventional, household.[26]

Giulia Farnese left the imprint of ownership on two fortified castles she inherited upon the death of her husband in 1500: the Castello Orsini in Vasanello and the Rocca Farnese in Carbognano (a gift from Alexander VI), both near Viterbo,

Fig. 8
Lock of Lucrezia Borgia's Hair
casket on a malachite stand
casket height 11¹³/₁₆ in. (30 cm)
Pinacoteca Ambrosiana, Milan
inv. 282

not far from Rome. The little-known interior decorations of both residences are of interest in this effort to decipher the Borghese portrait. The most prominent attribute of the unknown young woman in Raphael's painting is the docile unicorn she holds in her lap.[27] A medieval symbol of purity, this mythical beast was adopted as a heraldic emblem by the Farnese in the mid-fifteenth century: unicorns are present in carved reliefs on the tomb of the patriarch, Ranuccio Farnese il Vecchio (ca. 1449–50),[28] and in the stemma of Pier Luigi Farnese the Elder, Giulia's father, on the city gate of Ischia (a family stronghold), where a unicorn hovers above a shield emblazoned with the Farnese fleurs-de-lis. In works commissioned by her brother Paul III during his pontificate the unicorn abounds,[29] but Giulia, who died ten years before Cardinal Alessandro Farnese became pope, appears to have employed it as a personal device decades earlier—an ironic, or perhaps defiant, choice for the decidedly unchaste *Sponsa Christi* (Bride of Christ), as she was derisively anointed in Rome. This appropriation is evidenced in the decoration of the *salone* of Vasanello, in which pairs of unicorns inhabit the circular frieze below the painted ceiling (fig. 9), and again in Giulia's apartments in Carbognano

(fig. 10), where spirited white unicorns and blonde-haired maidens clad in flowing draperies imprinted with Farnese lilies cavort in the lunettes.[30]

In addition to this familial allusion to the Farnese, Renaissance images of unicorns continued to carry the less personalized, ancient association with purity and virginity. Leonardo da Vinci in one of his notebooks recounted the legend that only a virgin could subjugate a unicorn, a wild beast by nature, which "for the delight it has for young maidens, forgets its ferocity and wildness; and laying aside all fear it goes up to the seated maiden and goes to sleep in her lap"[31] Cesare Ripa's *Iconologia* repeats the wisdom that the unicorn would allow only a virgin to approach it.[32] As symbols of chastity, unicorns appear frequently in female portraits of the period. Examples include the reverse of Pisanello's medal of Cecilia Gonzaga showing a maiden with a tamed unicorn resting in her lap, and the portrait of a woman, possibly Ginevra d'Antonio Lupari Gozzadini, attributed to a late fifteenth-century Emilian painter known as the Maestro delle Storie del Pane, in which a background vignette depicts a young woman approaching a submissive unicorn.[33] A more elaborate visualization is the *Triumph of Chastity*, a subject taken from Petrarch's *Trionfi*, on the reverse of Piero della Francesca's portrait of Battista Sforza, wife of Federico da Montefeltro, Duke of Urbino, which portrays the triumphal chariot drawn by two unicorns[34]—a poetic tableau that once again announces the chaste and virtuous nature of the sitter depicted on the other side of the panel. If the young woman in Raphael's portrait is Laura Orsini della Rovere, the unicorn she holds assumes a dual meaning: a conventional attribute of female virtue, it is also a heraldic reference to the particular sitter's lineage.

That lineage was paramount in late 1505 and 1506—the date of Raphael's portrait—when Laura wed Niccolò Franciotti della Rovere, a nephew of Pope Julius II (reg. 1503–13). The marriage ceremony was performed in the Sala dei Pontefici (the large audience chamber adjoining the Borgia apartments in the Vatican palace) in the presence of the pope, eight cardinals, and other dignitaries on 16 November 1505.[35] Official celebration of the nuptials continued well into the following year.[36] For the Farnese, the marriage to a papal nephew of the often and expediently betrothed Laura, whose most recent matrimonial contract had been canceled in order to permit a more advantageous match, represented a new apogee in the family fortunes.[37] For the pope, author of a calculated "scheme of intermarriage to old Roman families,"[38] it meant strengthened alliances with both the Orsini, one of the most ancient and bellicose Roman princely houses, and the increasingly powerful Cardinal Alessandro Farnese, the bride's uncle, as well as a significant advance in the ascent of his parvenu (by Roman standards) della Rovere relations.[39] The abovementioned ceiling decoration carried out for Giulia Farnese in the castello at

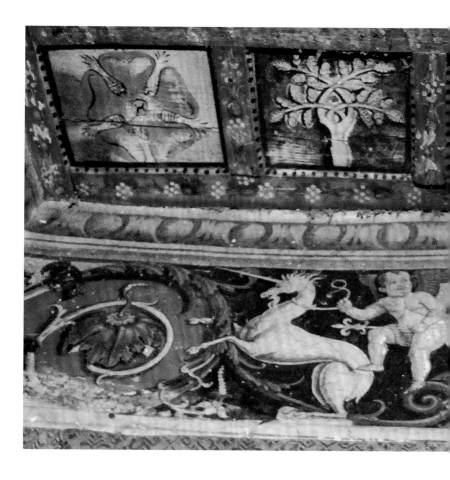

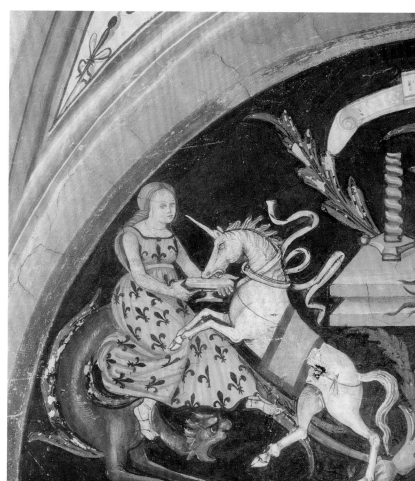

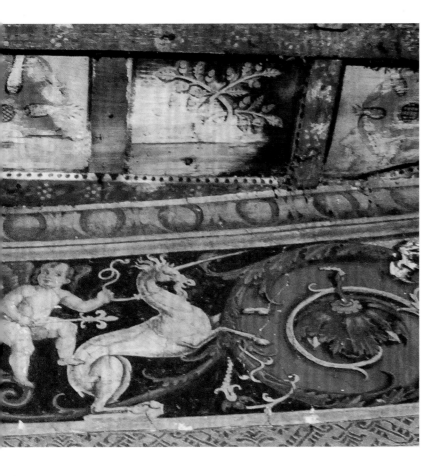

Fig. 9
Unicorn Frieze
Salone of Castello Orsini,
Vasanello, Italy

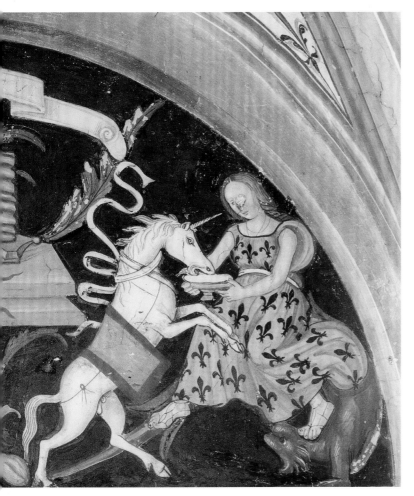

Fig. 10
Women with Unicorns
Studiolo of Giulia Farnese,
Castello (Rocca) Farnese,
Carbognano (Viterbo), Italy

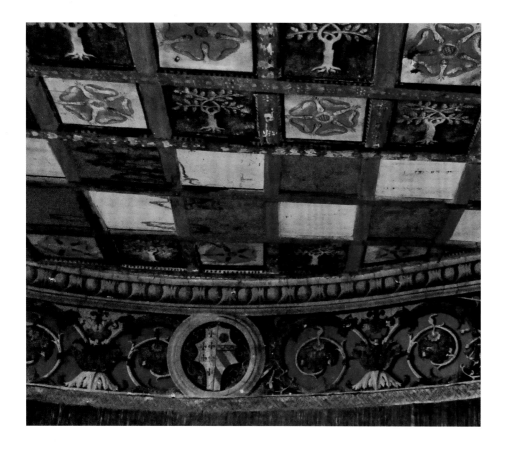

Fig. 11
Ceiling of Castello Orsini,
Vasanello, Italy

Vasanello, probably on the occasion of the marriage or at least to commemorate it, celebrates this felicitous union: the coffers are painted with alternating Orsini red roses and della Rovere oak trees, while Giulia's own noble pedigree is announced in the heraldic shields in the frieze displaying the colors and *scudo accolato* (impaled coat of arms) of the Orsini and Farnese (fig. 11).⁴⁰

Given Laura's dubious parentage (and Julius's deep antipathy for his predecessor Alexander VI and all things Borgia), it would have been imperative that her Orsini lineage be considered unimpeachable. The decorations at Vasanello trumpeted this message. In one segment, the Orsini bear makes a rare appearance, engaged in what appears to be a conversation with a Farnese unicorn before a backdrop of della Rovere acorns—the full familial constellation captured in a heraldic vignette.⁴¹ Elsewhere, on one of the painted ceilings, the heraldic colors of the Orsini, red and white, are displayed in the square fields embellished with the Orsini rose and in Giulia Farnese's stemma (see figs. 9 and 11). If the subject of Raphael's contemporaneous portrait is Laura Orsini, her voluminous red-and-white sleeves (fig. 12) would have been recognized as a heraldic device—

Fig. 12
Raphael
Portrait of a Lady with a Unicorn (detail)
ca. 1505–6

and thus as confirmation of her impeccable (if dubious) Orsini bloodline.[42] The unicorn would have carried a comparable symbolic import, denoting Laura's Farnese descent in addition to her virginal purity.[43] (Although Laura's patronymic was Orsini, she was occasionally referred to in contemporary written sources as Laura Farnese—for example, in a letter to Baldassare Castiglione in which the poet Antonio Tebaldeo calls her "Madonna Laura Frenese."[44]) And finally, if a plausible scenario for the *Lady with a Unicorn* has been formulated here, Laura's contractual betrothal and marriage in November 1505 was the catalyst for the commission, as was the case with many female portraits of the period.[45] At the time those negotiations were underway, Laura Orsini was thirteen years old—an eminently plausible age for the sitter in the portrait.

It is necessary to ask if support for this argument can be adduced from other details in the painting itself or collateral to it. One piece of information to weigh is the Aldobrandini provenance. Although the picture's whereabouts before 1623 are unknown, this ownership history offers a potential path back to the Farnese, given that, as noted earlier, the two families were linked by marriage: the portrait may have passed from a Farnese descendant to the Aldobrandini (losing its identity along the way). However, the absence of any documentary evidence, and the convoluted family trees, at present thwart an exploration of such a hypothesis.[46]

A more fruitful avenue of inquiry lies in the jewels and adornments worn by the sitter in the portrait. It has not been previously observed that her waist is cinched by a gold-clasped marriage belt or girdle, a very particular item of clothing symbolizing marriage and fertility, and which was part of a bride's attire (fig. 13).[47] This element of her costume is tangible evidence that the work commemorates a betrothal or marriage.[48] The striking gold chain with an elaborate enameled and jeweled pendant suspended from the sitter's neck, and her gold hair brooch, also connote the ritual of marriage. Signs of a family's wealth and social standing,

Fig. 13
Girdle with Profiles of Half-Length Figures
ca. 1400
basse taille enamel, silver-gilt, mounted on textile belt
69 × 1 × ¹¹/₁₆ in.
(175.3 × 2.5 × 1.7 cm)
The Metropolitan Museum of Art, New York
Gift of J. Pierpont Morgan, 1917
17.190.963

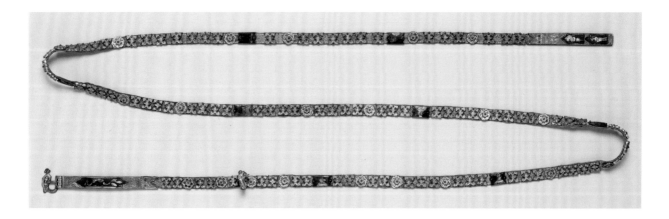

such costly gems and ornaments were given in connection with a betrothal. These formed part of a woman's dowry and are frequently worn by their recipients in nuptial portraits (see fig. 2). Indeed, one scholar has aptly described such bejeweled young women as "dowry-bedecked."[49] Certain jewels were pointedly associated with marriage. Pearls were symbols of virginity and purity, rubies of prosperity and fertility, and sapphires of fidelity. These resonant associations made them particularly suitable as weddings gifts.[50] Their ubiquity in a nuptial context is attested in fifteenth-century documents concerning trousseaus and dowries and corroborated by the visual evidence offered in Renaissance portraits, including the *Lady with a Unicorn*, in which the sitter is resplendent in her pearl, ruby, and sapphire pendant. What is more, the particular jewels represented may point expressly to Laura Orsini.

A document of 12 December 1505 concerning an inherited debt Laura Orsini owed to the Chigi bank in Rome itemizes jewels and other valuables belonging to her mother, Giulia Farnese, that were offered as collateral. Among them are a gold mesh chain and a clip or pendant with a diamond, a ruby, and three hanging pearls.[51] If Laura Orsini is the subject of Raphael's portrait, the prominent pearl-and-ruby pendant and the gold mesh chain worn by the sitter were meant to allude to—and in the case of the chain, literally depict—jewels that were in her family's possession.[52] Inherited from Giulia Farnese and from Adriana de Mila, these were part of Laura's dowry, as stipulated in a revision to the above-cited 1505 nuptial agreement notarized by Camillo Benimbene, drawn up on 15 June 1506.[53] Although not necessarily one of a kind (similar pearls and gems appear in many portraits of the period), the jeweled ornaments have a specificity that must be acknowledged: these are meant to be recognized not as generic props, but as real jewels belonging to the real person represented. That Laura Orsini della Rovere is documented as having owned jewels of the precise type conspicuously displayed in the portrait—a large ruby, a hanging pearl, a gold mesh necklace—augments the case for her as its subject.[54]

This discussion has posited some connection with Urbino for the commission of the portrait. In this context, too, Laura Orsini remains a plausible candidate for its subject, given her marriage at the very time it was painted to a della Rovere—the designated new ruling family of the duchy of Urbino, whose status and prestige the pope himself, its patriarch, was determined to promote. The wedding celebration of Laura to Julius's nephew Niccolò Franciotti della Rovere was a topic of interest and conversation at the court of Urbino: in a letter of 12 June 1506, Emilia Pia recounted amusing gossip about the festivities to her sister-in-law, the duchess Elisabetta Gonzaga.[55] The same letter also reports on the contemporaneous

nuptials of the pope's daughter, Felice della Rovere, and Gian Giordano Orsini, mentioning that Giulia Farnese and her daughter, Laura, were in attendance.

Emilia Pia and Elisabetta Gonzaga each appear as protagonists in Baldassare Castiglione's *Book of the Courtier*, a series of dialogues set in Urbino in the year 1507, and both have been identified as the subjects of portraits attributed (somewhat problematically) to Raphael.[56] Another member of their circle was Giovanna Feltria della Rovere, the "Prefetessa," sister-in-law of Julius II (who opined of her, none too kindly, that she was "crazy and insolent"[57]). A discerning patron, she was a particular champion of Raphael, as both the works he is believed to have painted for her and the letter she is reported to have penned on his behalf when he departed for Florence make clear. It has been proposed that she may have been responsible for commending the painter to her irascible brother-in-law the pope.[58] Perhaps she also played some part in the commission of the *Portrait of a Lady with a Unicorn*. But even without the Prefetessa's intervention, a portrait of Laura Orsini della Rovere—and the artist who painted it—would have been of interest to Julius II, given his solicitation of that particular della Rovere bride. Indeed, it is just possible that Julius himself could have been behind the commission, with or without the Prefetessa as intermediary. Castiglione recounts that the Pope and a retinue of cardinals and courtiers passed through Urbino in 1506, where they were "received with all possible honor and with as magnificent and splendid a welcome as could have been offered in any of the noble cities of Italy," and that the pleasant evening conversations that inspired the *Book of the Courtier* began on the day following his departure.[59] That papal stopover may well have coincided with one of Raphael's own known visits to Urbino in this period. Such an encounter, if it occurred, was the fateful prelude to the painter's summons to Rome a short time later.

Although the lady with a unicorn is assuredly a particular person rather than an imagined *bella donna* (a designation describing idealized portrayals of female beauty as distinct from literal likenesses of actual sitters[60]), the depiction of her is not devoid of poetic associations. If the subject is the Roman-born-and-bred Laura Orsini, this is an image of a sitter that Raphael probably had not seen.[61] The subject's physical aspect therefore was not observed *dal vero*, but was instead summoned from the artist's imagination,[62] though perhaps on the basis of a description. With her striking golden hair and aloof refinement, the young woman in the portrait resonates with Petrarch's description of his beloved, ever-remote Laura, whose defining physical trait was her "lovely blonde hair."[63] Indeed, the subject's entire aspect—the fair skin; slightly rosy cheeks; small, delicate mouth; curling tresses; high, smooth forehead; large, limpid eyes; and soft, graceful shoulders—conforms in its specifics to a Petrarchan canon of female beauty.[64]

Petrarchan ideals of love and beauty, like Petrarchan modes of lyric poetry and graceful language, were espoused across Italy in the early decades of the sixteenth century—and nowhere more intelligently than at the erudite and cultured court of Urbino, where Petrarch's eloquent champion, the humanist and poet Pietro Bembo, resided in the period when Raphael painted the *Portrait of a Lady with a Unicorn*. Had the painter himself been unaware of the glimpses of Laura offered up in the *Canzoniere*, he could have found no better tutor than Bembo, and in the effort to formulate an image of chaste, ideal beauty—itself a mirror of inner virtue[65]—no more apposite model than the poet's paragon. This Petrarchan synecdoche is a recurring conceit in Renaissance portraiture. Every *bella donna*, real or imagined, had a little Laura in her, and every artist who painted a beautiful woman, a little Petrarch.[66]

· · · · ·

On the basis of the painting's chronology and myriad visual clues—allusions to Urbino; the conjectured sitter's biography and physical appearance; heraldic references to the Farnese and the Orsini; accoutrements and details of dress associated with matrimony; correspondence with material possessions belonging to Giulia Farnese and her daughter—this essay has proposed that Raphael's *Lady with a Unicorn* is a portrait of Laura Orsini della Rovere, commissioned to commemorate her betrothal in November 1505 to the nephew of Pope Julius II, Raphael's future patron in Rome. The portrait is a likeness, but one that describes the subject's pedigree, elevated social status, and virtuous character as much as her outward physical appearance.[67] These temporal references to the specific sitter are in turn accorded a transcendent timelessness through the Petrarchan overlay— the allusions to the poet's Laura. In this duality lies Raphael's response to the two "key functions" of portraiture: "the demands of immediate recognition with those of long-term recollection."[68] Given that the identity of the lady with a unicorn was forgotten centuries ago, the imperative of memory, irredeemably compromised once the portrait was removed from its physical and familial framework, was not, in the end, served. Or perhaps Raphael had in mind the truism later articulated by Michelangelo, who responded when criticized for the distinctly non-portrait-like features of the Medici *Capitani* in the New Sacristy that literal likeness mattered little, since no one would remember what they had actually looked like a thousand years hence. Unlike Michelangelo, however, Raphael did strive for recognition, endowing his sitter with the defining features of both the actual and the poetic Laura[69]—of Laura Orsini della Rovere and of Petrarch's beloved Laura. In either incarnation, the *Portrait of a Lady with a Unicorn* is a portrait of Laura in a loggia.

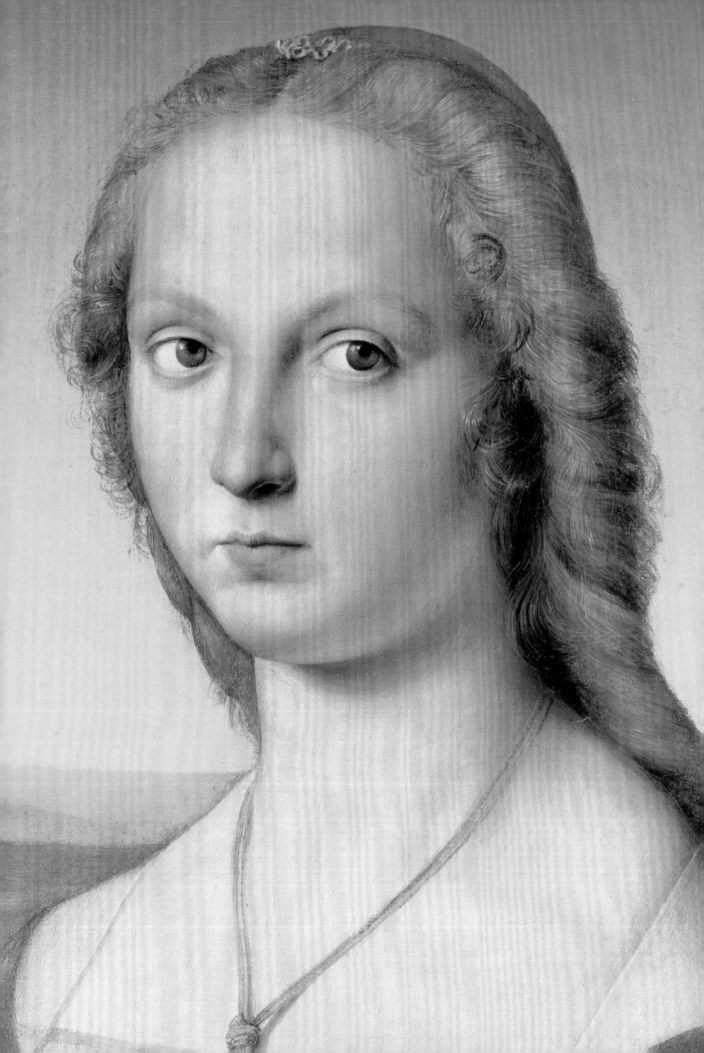

The Lover Entrapped

Virtue and Vice in Raphael's
Portrait of a Lady with a Unicorn

MARY SHAY-MILLEA

"Her tranquil eyes, her eyebrows lit by stars, / her mouth, angelic, beautiful, and full of pearls and roses and sweetness of words / that make a person tremble in amazement, / and then her forehead and her hair which seen in summer at high noon put out the sun."[1] Though written in the mid-fourteenth century in honor of another woman, Petrarch's poetic words extolling his beloved Laura could equally be read as a description of the blonde beauty depicted in Raphael's *Portrait of a Lady with a Unicorn*, painted about 1505–6.[2]

Petrarch, together with Dante Alighieri and Giovanni Boccaccio, was one of the esteemed *tre corone*, or three crowns, of Trecento authors who wrote in vernacular Italian. Yet unlike Dante, whose beloved Beatrice leads him to spiritual enlightenment, Petrarch is led astray by his lustful pursuit of Laura in his collection of love poems, *Il canzoniere*, sometimes referred to as the *Rime sparse*. This personal approach to love appealed to a courtly Renaissance audience who strove to imitate the unrequited relationship between Petrarch and Laura. In the spirit of *Petrarchismo*, fifteenth- and sixteenth-century poets mimicked Petrarch in their verse, while courtiers emulated the romantic relationship between Petrarch and Laura in real life. Platonic couples exchanged love sonnets and portraits, and some women went so far as to transform themselves into versions of Laura, brewing potions to lighten their hair and whiten their skin, and using tweezers to create the unnaturally high forehead praised by Petrarch. All these features, and others described as Laura's, can be seen in Raphael's *Portrait of a Lady with a Unicorn*.[3]

Ironically, though Laura became the standard for female pulchritude in the Renaissance, what she actually looked like is impossible to reconstruct, even

Raphael
Portrait of a Lady with a Unicorn (detail)
ca. 1505–6

with Petrarch's countless references to her exquisite features. As did Zeuxis in portraying Helen of Troy, Petrarch borrowed the loveliest qualities of multiple women in order to describe the perfect beauty. Laura's golden hair, eyes like stars, rosebud mouth, pearly teeth, and exceptionally long neck, when combined, painted a strange picture that provoked numerous parodies in contemporary poetry, including a sonnet by Michelangelo that poked fun at the Petrarchan ideal by praising a lady's cheeks like "radishes a-blush Teeth, sweet corn / buttered, row and row [and] hair pale as frizzy onions in their bin."[4] Petrarch's own view of Laura was equally paradoxical. She was variously a virtuous lady, a virginal madonna, an ideal beauty, a seductress, and a symbol of his pursuit of poetic fame and the classical laurel crown (*lauro*).[5] This conflicting image of Laura conveniently allowed both proper and improper Renaissance ladies to emulate her beauty and offered early modern artists and patrons various contradictory interpretations of Laura, enabling them to eroticize some women while putting others on a pedestal. Laura was the perfect model for Renaissance portraitists because her features were specific enough to be recognizably Petrarchan, yet flexible enough to apply to a standard of beauty that could be adjusted to meet the needs of various types of relationships and interpretations of ideal beauty.

In addition to Petrarch's description of Laura's idealized features, the *Canzoniere* includes two sonnets in honor of her portrait commissioned by Petrarch from his friend Simone Martini. The portrait, according to Petrarch, was so beautiful that "only up in Heaven / could [it] be imagined"[6] Though the portrait did not survive into the Renaissance, and some believe it never existed, its lore held particular appeal for later fifteenth- and sixteenth-century humanists who were inspired to commemorate their own beloveds in a similar fashion. Raphael's *Lady with a Unicorn* belongs to this genre of female portraiture inspired by Laura and often accompanied by love sonnets in the manner of Petrarch. Raphael himself wrote a series of Petrarchan sonnets in honor of his own beloved. One describes her with the same "countenance of white snow and fresh roses . . . [and] white arms" represented by his painting.[7] Though this tradition was still thriving during Raphael's time, at its inception it was a Florentine invention, beginning at the court of Lorenzo de' Medici. Contemporary Petrarchan sonnets document Lorenzo's commission of a portrait of his Neoplatonic beloved, Lucrezia Donati, from Andrea del Verrocchio sometime before 1488, when the portrait (now no longer extant) was recorded in the artist's Medici inventory. This began a Renaissance tradition of commissioning a portrait of a beautiful woman in the style of Laura and commemorating the sitter and her male beloved in Petrarchan verse.

Raphael was certainly inspired by Florentine examples of Petrarchan beauties when he painted his *Lady with a Unicorn*; however, no Florentine artist had more influence on his portrait than Leonardo da Vinci. Leonardo returned to Florence from Milan in 1500, shortly before Raphael arrived in the city in 1504. Raphael's admiration for Leonardo, and undoubtedly his desire to establish himself as the older master's equal, may explain in part Raphael's inclusion of a unicorn in the hands of his sitter. When considered alongside two earlier Petrarchan portraits by Leonardo, it becomes evident that both Raphael and Leonardo toy with opposite ends of the same Petrarchan spectrum of beauty, propriety, love, and lust.

Leonardo's first documented Petrarchan beloved portrait, painted circa 1474–78, depicts the young Florentine beauty Ginevra de' Benci (fig. 14).[8] The portrait was commissioned by the Venetian Petrarchist Bernardo Bembo as a commemoration of his Neoplatonic love for Ginevra, following Lorenzo de' Medici's example. Ginevra faces forward, golden-brown waves framing the alabaster skin of her lovely face. In the background, a halo of juniper (*ginepro*) cleverly puns on Ginevra's name, just as Petrarch interchanged Laura's name with the poetic laurel crown (Laura/*lauro*) throughout the *Canzoniere*. Although the painting is now cut off below Ginevra's shoulders, the original probably showed her holding a small bunch of flowers, making this the first extant painted portrait to include hands.[9]

On the reverse of Ginevra's portrait, Leonardo included Bembo's personal device—a wreath of laurel and palm encircling a juniper sprig; wrapped around the plant is a scroll bearing the motto "VIRTUTEM FORMA DECORAT" (Beauty adorns virtue).[10] However, it has been suggested that Leonardo may have originally intended to paint Ginevra with a unicorn on the back of the painting in order to celebrate her virtuous nature.[11] Two extant drawings are speculated to be sketches for this idea; both works, dating to the mid- to late 1470s, depict a young woman luring a unicorn into her lap. In the slightly earlier *A Maiden and a Unicorn* (now in the Ashmolean Museum, Oxford), the girl sits in a natural landscape and looks toward the viewer while she holds the unicorn by a leash in one hand and points to him with the other (fig. 15).[12] The composition of the later drawing, held in the British Museum, is similar, though the girl now pets the unicorn with both hands. The inclusion of the unicorn on the back of Ginevra's portrait would have underscored her chaste relationship with Bembo, as she was a married woman at the time the portrait was painted. It also could be a metaphor for her power to lure Bembo into her lap with her virtue and beauty, thus "capturing" the greatest Petrarchan poet of her time.

About 1488–90, Leonardo was commissioned by the Milanese duke Ludovico Sforza to paint a Petrarchan beloved portrait—inspired, like Leonardo's earlier

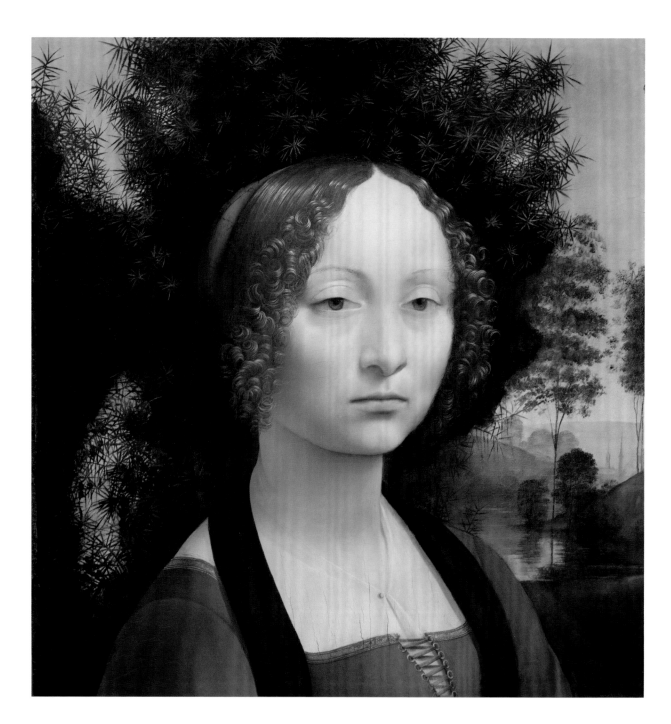

Fig. 14
(above)
Leonardo da Vinci (1452–1519)
Portrait of Ginevra de' Benci (obverse), ca. 1474–78
oil on panel
15 × 14 9/16 in. (38.1 × 37 cm)
National Gallery of Art, Washington, DC
Ailsa Mellon Bruce Fund, 1967.6.1.a

Fig. 15
(right)
Leonardo da Vinci (1452–1519)
A Maiden and a Unicorn, late 1470s
pen and dark brown ink on white paper
3 3/4 × 2 15/16 in. (9.5 × 7.5 cm)
The Ashmolean Museum, Oxford
Presented by Chambers Hall, 1855, WA1855.83.1

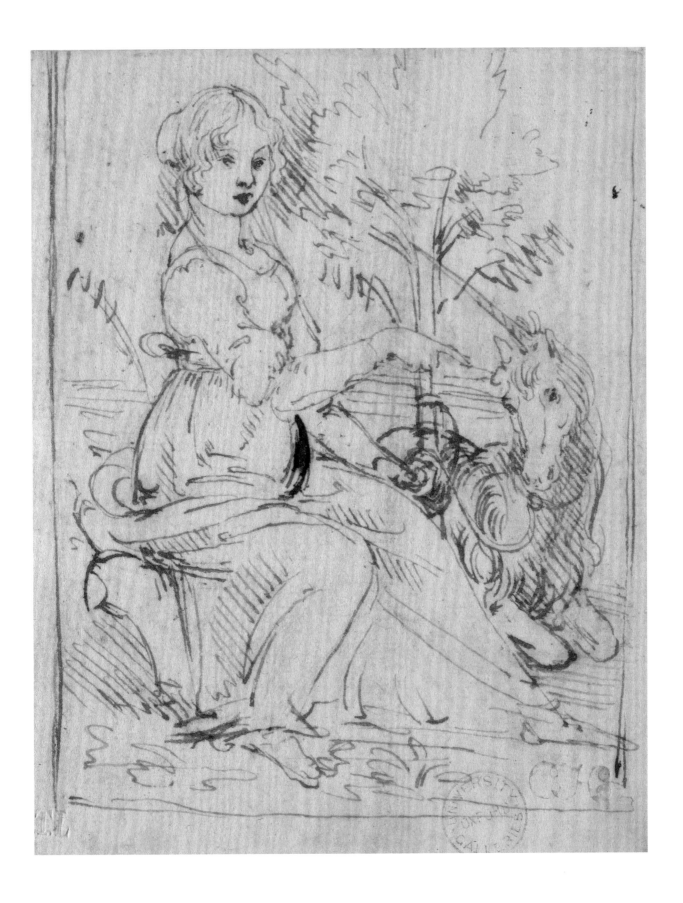

Portrait of Ginevra de' Benci, by the Florentine model established by Lorenzo de' Medici—of Sforza's mistress, Cecilia Gallerani (known as *Lady with an Ermine*, fig. 16). Though Cecilia's hair is not the bright golden hue praised by Petrarch and represented by Raphael's *Lady*, she retains the high forehead, long neck, and porcelain skin prized in Petrarchan poetry. Yet it is the focus on Cecilia's bare hand that accentuates her Petrarchan allure. Hands were a popular Petrarchan conceit, used throughout the *Canzoniere* to symbolize Laura's erotic attraction and Petrarch's sexual frustration. Bare hands were especially alluring for Petrarch, and often he would revel at the sight of Laura's elegant white hands exposed to his gaze, as in Sonnet 199: "Those fingers long and soft which naked now / luckily Love shows me for my enrichment."[13]

Leonardo clearly was aware of the dichotomy in the *Canzoniere* between naked, unoccupied hands and demurely placed hands like those he presumably painted on the now-missing lower portion of his earlier *Portrait of Ginevra de' Benci*. Unlike Ginevra, who likely held a bouquet of flowers offered as a gift to her Neoplatonic beloved Bernardo Bembo, Cecilia's hands are charged with sensuality as she strokes a live, white ermine. This was no doubt because Cecilia Gallerani was Ludovico Sforza's mistress, not an unobtainable beloved like Ginevra.[14] Just as Leonardo used the juniper bush to name Ginevra, the ermine is a pun on Cecilia's surname, Gallerani, and the Greek word for ermine, *galé* (γαλη). The ermine is also thought to be a metaphoric representation of Ludovico Sforza, who adopted the animal as one of his personal emblems and was sometimes called "L'Ermellino."[15] The dominant role of the ermine in the painting, and the way Cecilia strokes its fur and cradles it in her arms, may refer to her intimate relationship with L'Ermellino and her cherished position as his favorite, in spite of the fact that Ludovico was a married man.[16] Cecilia's sensual stroking of a creature historically associated with the three highly valued feminine traits of chastity, purity, and moderation further charges the painting with a complexity equal to Petrarch's own complicated fusion of eroticism and chastity in his poetic descriptions of Laura.[17]

The inclusion of the ermine in Cecilia's portrait was intended to be read on multiple symbolic levels. In addition to the witty play on her surname and her lover's nickname, the animal might allude to Cecilia's affair with Ludovico, the imminent birth of their illegitimate child, and the jealous nature of Ludovico's wife Beatrice by referencing a myth from Ovid's *Metamorphoses*, in which Juno punishes her husband Jupiter's mistress, Alcmene, by turning her into an ermine and forcing her to give birth to her illegitimate son, Hercules, through her mouth.[18] An erudite viewer would have considered the ironic parallels between Cecilia's pregnancy and Ovid's description of Jupiter's jealous wife.[19]

Fig. 16
Leonardo da Vinci
(1452–1519)
Lady with an Ermine
ca. 1490
oil on wood
21 × 15½ in.
(53.4 × 39.3 cm)
Czartoryski Museum,
Kraków, Poland

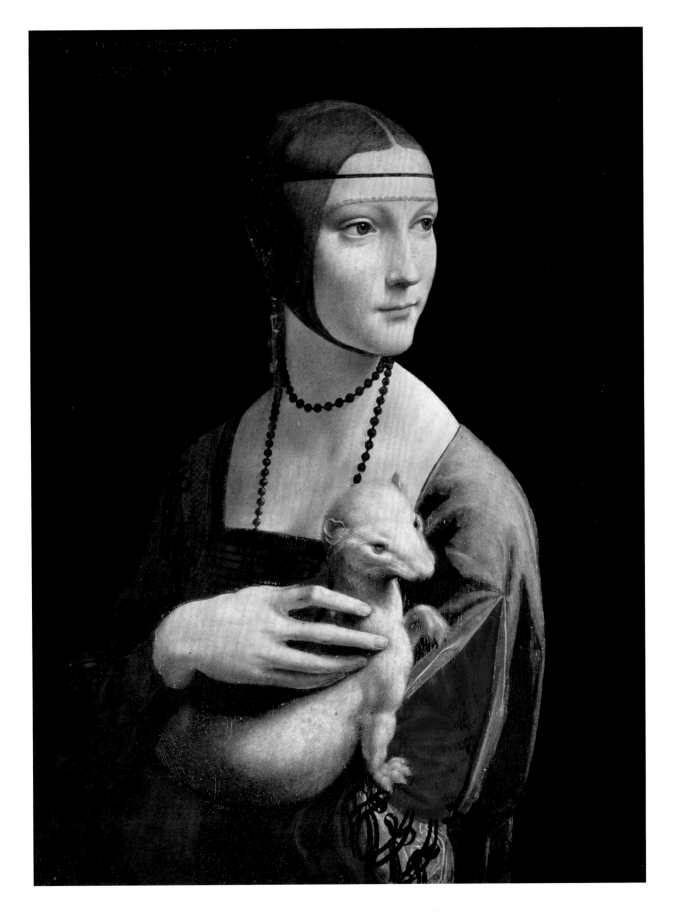

So, too, should the unicorn be considered as a complex metaphor in Raphael's portrait. Though Raphael painted his *Lady with a Unicorn* more than a decade after Leonardo's *Lady with an Ermine*, he was certainly aware of that portrait through his friendship with Leonardo. The unicorn in Raphael's Lady's hands is equally alluring and metaphorically complicated. Raphael was no doubt aware that both the ermine and the unicorn were included in widely read and illustrated medieval bestiaries that presented a Christianized version of the ancient Greek *Physiologus*—a natural history of animals, real and fantastical, written anonymously in the first half of the second century AD and translated into Latin in the fourth century. The unicorn and the ermine (which is also called a weasel) are numbers thirty-five and thirty-six of the approximately fifty-one creatures, plants, and stones included in the text. The adjacent proximity of the entries meant that the animals were associated with one another both visually and contextually.[20] Like the ermine, the unicorn was associated with virginity. According to ancient lore, the unicorn was attracted by purity and could be lured only by a virgin. Once contained in the maiden's lap, the unicorn could be then captured by hunters and brought to the king.

A courtly version of the *Physiologus* titled *Bestiaire d'amour* (Bestiary of Love) should also be considered in a discussion of the animals. Written by Richard de Fournival in the mid-thirteenth century, the *Bestiaire d'amour* presented the *Physiologus* through the lens of the French chivalric love tropes popular at Fournival's time and later adopted by Petrarch in his *Canzoniere*. In Fournival's version, the ermine story is interpreted as a metaphor for a male suitor's ability to seduce a woman with his words, thus "they [women] have heard so many fair words that they feel bound to grant their love (and have thus conceived by ear as it were), they then deliver themselves by mouth of a refusal"[21] Fournival compares his own seduction into love using the unicorn metaphor: "For I had been the haughtiest young man of my generation toward Love, and I thought I had never seen a woman that I would want for my own, a woman I would love as passionately as I had been told one loves. Then Love, who is a clever hunter, put a maiden in my path and I fell asleep at her sweetness and I died the sort of death that is appropriate to Love, namely despair without expectation of mercy." This scene is illustrated in a circa 1290 Northern Italian *Bestiaire d'amour* (fig. 17) now in the Pierpont Morgan Library.[22] A maiden sits with a unicorn tucked into her lap while a hunter raises his lance to slay the beast from behind. The weasel is later interpreted in the *Bestiaire d'amour* as a mother licking its young in order to bring it back to life according to Fournival's claim that a weasel can magically resuscitate its own young.[23]

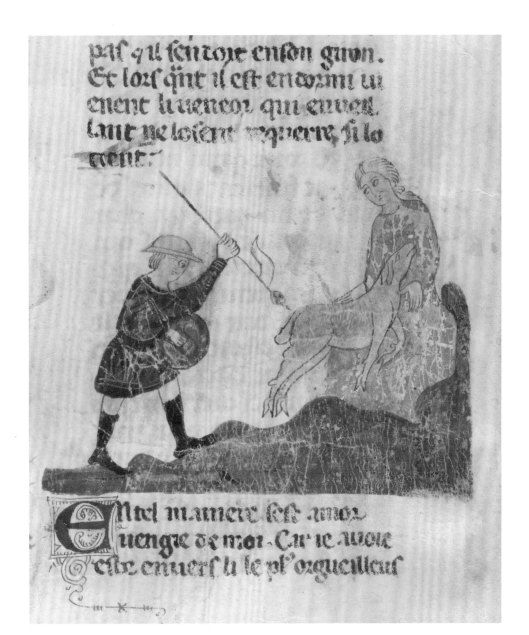

In 1494, Leonardo wrote his own moralizing version of a bestiary called *Studies on the Life and Habits of Animals* in his Manuscript H, now in the Institut de France in Paris. He assigned moralizing titles to select animals, associating the ermine with Moderation (*moderanza*), because it would "rather let itself be taken by the hunters than take refuge in a dirty lair, in order not to stain its purity," and the unicorn with Incontinence (*intēperanza*).[24] According to Leonardo, "the unicorn, through its intemperance and not knowing how to control itself, for the love it bears to fair maidens forgets its ferocity and wildness; and laying aside all fear it will go up to a seated damsel and go to sleep in her lap, and thus the hunters take it."[25] The ermine protects its purity above all else, and the unicorn is lured by its lust for a virgin into sacrificing its own life. Read in the context of Leonardo's and Raphael's portraits, Cecilia's reputation is simultaneously tainted and protected by Ludovico (L'Ermellino). She is given the honor of being painted alongside his

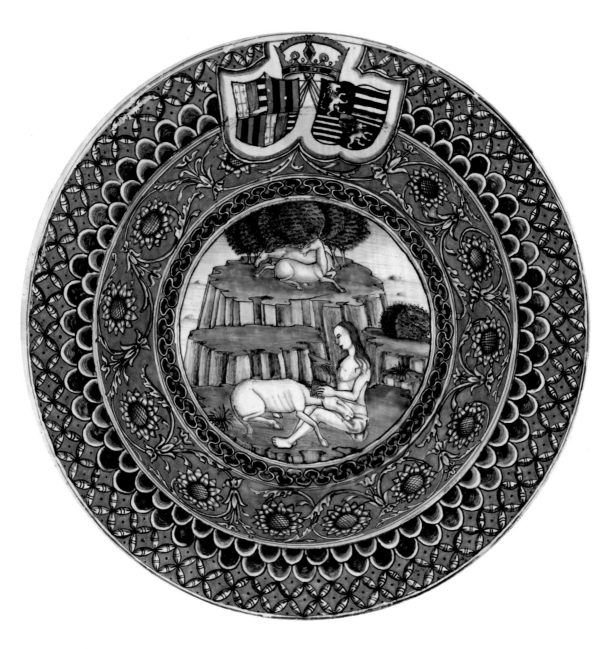

personal emblem and commemorated by Petrarchan sonnets in her honor in the style of Laura, yet the subtext is that the act of stroking L'Ermellino is how she ended up impregnated with his child. The inclusion of the unicorn in Raphael's *Lady* both advertises the sitter's purity and warns her future husband of her powers of seduction. Such powers are illustrated on a contemporary majolica dish (ca. 1486–88) illustrating the story of the Virgin and the Unicorn (fig. 18). The virgin sits naked in a grassy landscape, literally stripped down to only her erotic allure; a white unicorn, unable to resist the woman's scent, surrenders itself in her lap.[26]

The two animals also have Petrarchan connotations and were included in Renaissance illustrations of Petrarch's *Triumph of Chastity*. Though Petrarch does not mention either beast in his poem, Renaissance artists often depicted the chariot drawn by unicorns, as seen in a Florentine *desco da parto*, or birthing tray, produced in the workshop of Apollonio di Giovanni di Tomaso about 1450–60 (fig. 19).[27]

Fig. 18
Dish Depicting a Virgin and a Unicorn
Italian
ca. 1486–88
tin-glazed earthenware (maiolica)
height 4⅛ in. (10.5 cm)
diameter 18⅞ in. (47.9 cm)
The Metropolitan Museum of Art, New York
Fletcher Fund, 1946
46.85.30

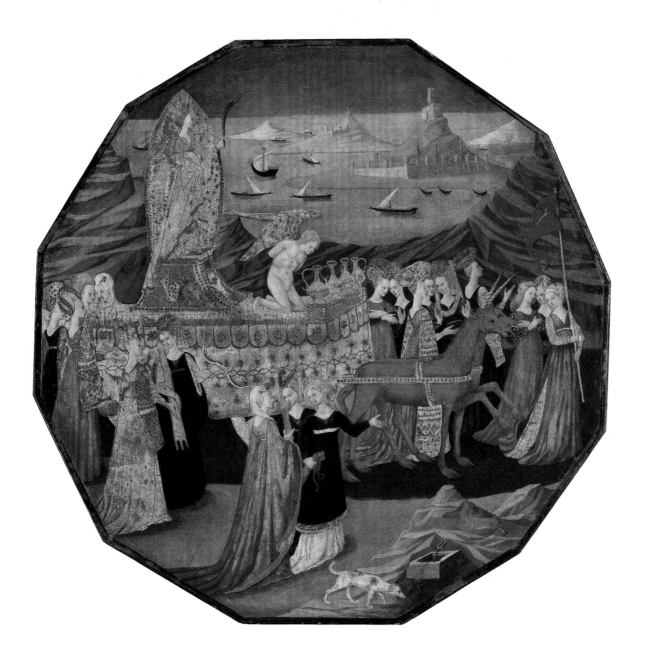

Fig. 19
Workshop of Apollonio
di Giovanni di Tomaso
(ca. 1416–1465)
Triumph of Chastity
ca. 1450–60
tempera and gold leaf
on panel
23 × 23¼ in.
(58.4 × 59.1 cm)
North Carolina Museum
of Art, Raleigh
Gift of the Samuel H.
Kress Foundation
GL.60.17.23

Both creatures are also featured prominently in Jacopo del Sellaio's *cassone* panel (ca. 1480–85), now in the Museo Bandini in Fiesole (fig. 20). Laura stands at the top of the chariot looking over Cupid and multiple virginal maidens below. Her chariot is pulled by a unicorn, above which flies a banner decorated with a white ermine in the central medallion. The inclusion of both the ermine and the unicorn was a Renaissance invention and clearly indicative of the Petrarchan associations attached to both animals. Perhaps Raphael's inclusion of the unicorn was meant to be a visual dialogue with Leonardo about the thin line between chastity and sin, virginity and eroticism, and proper and improper Petrarchan ideals. Just as an informed viewer would read the irony in the inclusion of a white ermine in a portrait of a well-known mistress, so too could the unicorn be read both as an advertisement of Raphael's Lady's purity and a warning that an attraction to the girl's feminine allure could in turn be a deadly proposition for a potential suitor,

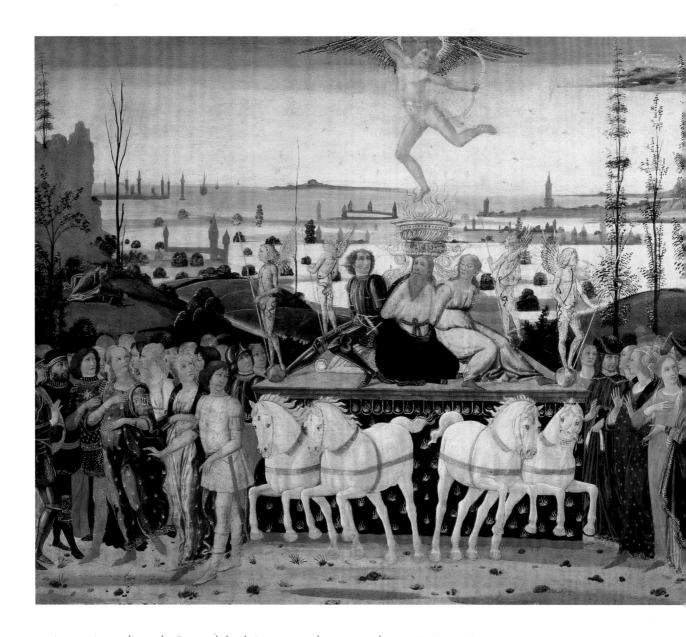

just as Laura brought Petrarch both immense pleasure and excruciating pain.

In her essay in this volume, Linda Wolk-Simon proposes that Raphael's Lady is Laura Orsini, daughter of Giulia Farnese (1474–1524). According to Wolk-Simon, the portrait was perhaps painted upon the occasion of Laura Orsini's marriage to Niccolò Franciotti della Rovere. The creation of such portraits was common among aristocratic couples; the intention was to advertise the young marriageable woman's best feminine features: her idealized good looks, her virtuous nature, and her virginity. Though Raphael's Lady is the picture of Petrarchan feminine perfection, her fingers intimately wrap around the unicorn's front legs, suggesting

Fig. 20
Jacopo del Sellaio
(1441/42–1493)
Triumph of Love and
Triumph of Chastity
ca. 1480–85
tempera on panel

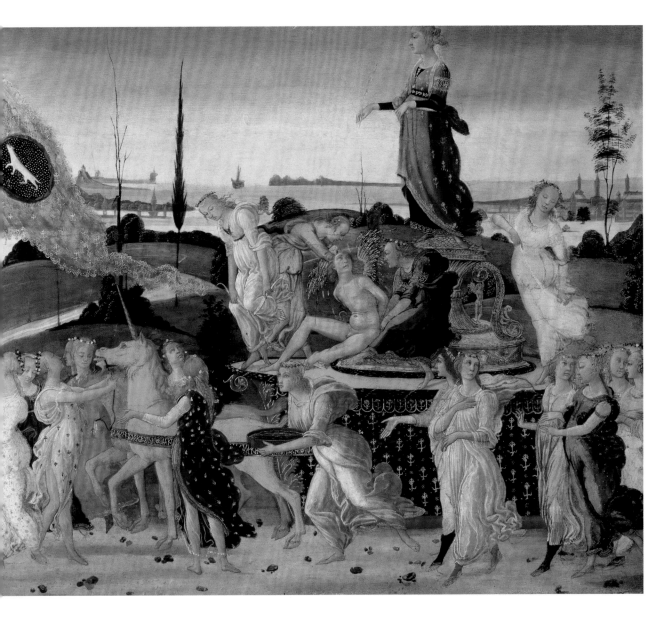

Triumph of Love panel
29¾ × 35¼ in.
(75.5 × 89.5 cm)
Triumph of Chastity panel
29¹⁵/₁₆ × 34⁷/₁₆ in.
(76 × 86.5 cm)
Museo Bandini, Fiesole,
Italy

that she has trapped the mysterious beast. Might this be an implied warning to her suitor that the Lady's power of seduction will be irresistible? If the sitter is, in fact, Laura Orsini, perhaps Raphael intended for the portrait to be read as a fusion of Petrarchan conceits: a portrait of Laura as Laura, literally triumphing over chastity by capturing the elusive unicorn with her feminine wiles. Regardless of who Raphael's mysterious sitter was, she nonetheless represents an erudite Petrarchan fusion of virtue and vice and the powers of feminine seduction that captures the intellectual spirit of a time ripe with Petrarchan associations— a virtuous virgin bursting with dangerous feminine allure.

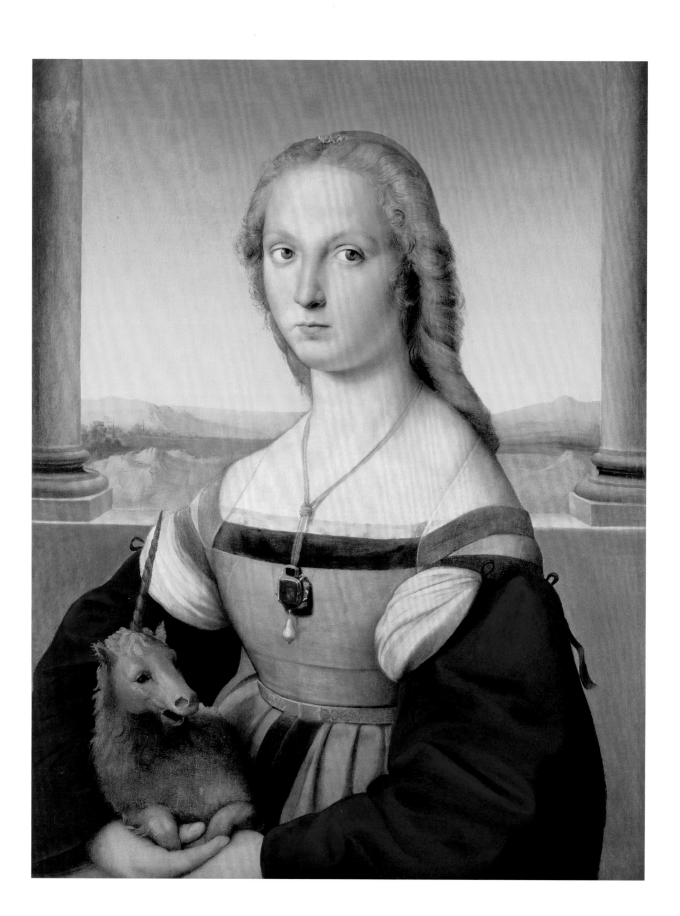

Portrait of a Lady with a Unicorn

Provenance

Olimpia Aldobrandini, Rome; Borghese collection, Rome, 1682

Conservation
History

As recounted by Jürg Meyer zur Capellen in his 2001 catalogue raisonné, in the late seventeenth century the portrait was overpainted, obscuring the unicorn and adding the attribute of Saint Catherine of Alexandria (pl. 2).[1] In 1936, the decision was made to remove this invasive addition, necessitating the removal of the underpainting and transferring the work from wood panel to canvas. In 1959–60, conservators attempted to treat and stabilize the painting, which was by then in a fragile state. Infrared photographs taken during this time indicate an earlier figure of a dog beneath the unicorn (pl. 3). Pentimenti, or alterations, are also apparent in the lady's face.

Plate 1
(left)
Raphael (1483–1520)
Portrait of a Lady with a Unicorn
ca. 1505–6
oil on canvas transferred from panel
26⅝ × 20¹⁵⁄₁₆ in.
(67.7 × 53.2 cm)
Galleria Borghese, Rome
inv. 371

Plate 2
(page 48)
Brogi
Portrait of a Lady with a Unicorn before restoration, as Saint Catherine of Alexandria
ca. 1900
Alinari Archives, Florence
BGA-F-011949-0000

Plate 3
(page 49)
X-radiograph of Portrait of a Lady with a Unicorn showing the dog underneath the unicorn

Plate 4
(page 50)
Raphael (1483–1520)
Portrait of a Young Woman
ca. 1505–6
pen and brown ink, traces of black chalk
8¾ × 6¼ in.
(22.2 × 15.9 cm)
Musée du Louvre, Paris
inv. 3882

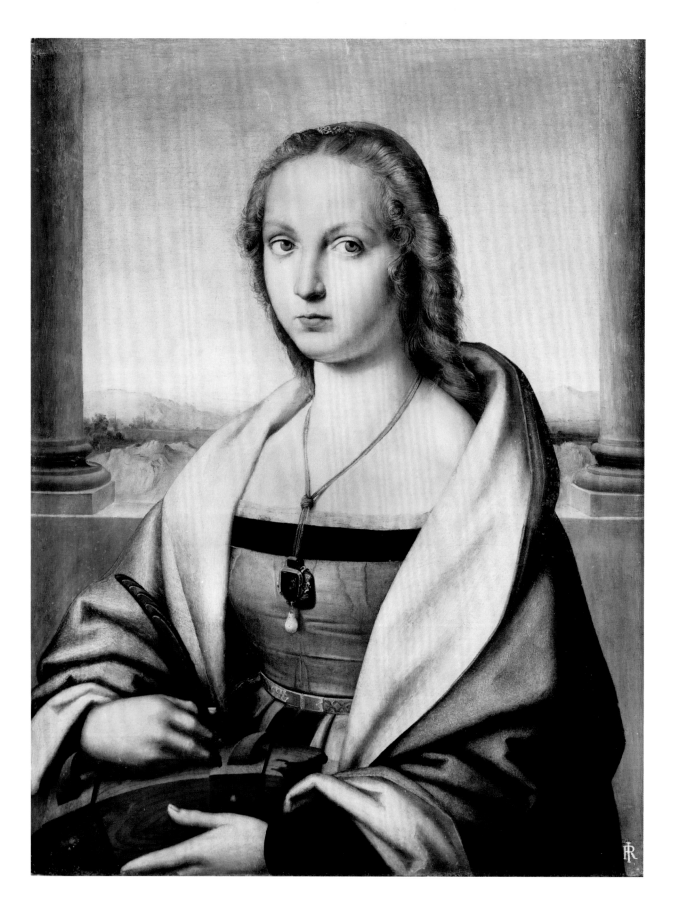

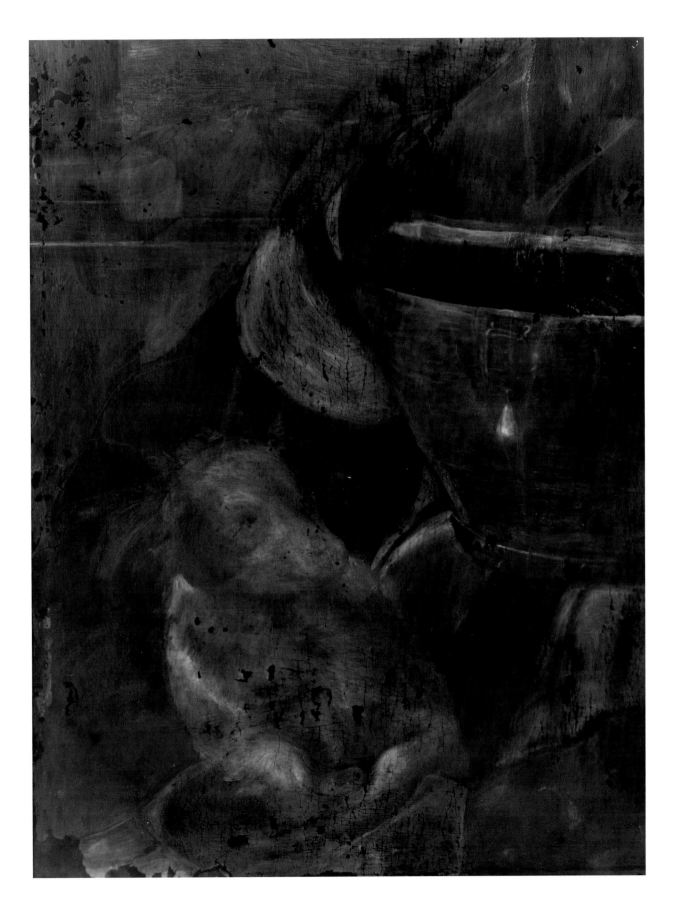

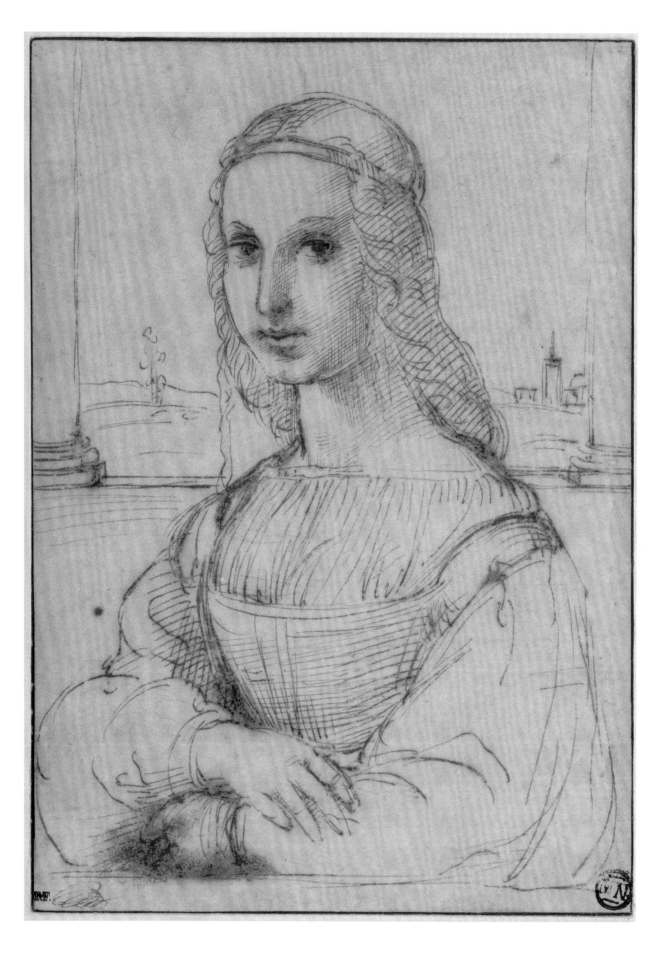

Notes

Laura in a Loggia

I am grateful to Esther Bell and Colin Bailey for inviting me to contribute this essay, and to Sheryl Reiss and Luke Syson for reading and commenting thoughtfully on the text.

1 Oberhuber 1999, pp. 80–81; Meyer zur Capellen 2001, 1:290–93, cat. no. 44; Tom Henry, in London 2004, p. 174, cat. no. 51; Marina Minozzi, in Rome 2006, pp. 123–25, cat. no. 10. Dussler 1971, p. 64, rejected Raphael's authorship and endorsed the often-proposed (and in my opinion untenable) alternative attribution to Ridolfo Ghirlandaio. In his *Vita* of Raphael, Vasari remarks that the artist painted portraits of an "infinite number" of women, a throwaway remark that in any case, from the context, applies to his Roman period and is therefore not relevant to the present discussion (V–M, vol. 4, p. 365).

2 No. 78: "Un quadro in tavola con una donna a sedere con Alicorno in braccio alto palmi uno e mezzo in circa con cornice nera di mano incerta." (Bon Valsassina in Bernini et al. 1984, p. 20; Meyer zur Capellen 2001, p. 290; Rome 2006, p. 125, in which an alternative transcription of the inventory—"una donna a sedere con Alicorno *in faccia*"—is proposed.)

3 Which, according to Meyer zur Cappellen 2001, happened in the late seventeenth century.

4 See ibid., p. 125, under no. 10, with reference to a 1623 Aldobrandini inventory in which the picture is listed. (The present author has not seen the then-forthcoming publication of this newly discovered inventory.) Prior to this document, the earliest known reference to the *Lady with a Unicorn* was the 1682 Borghese inventory.

5 See the most recent discussion by Tom Henry in London 2004, p. 174, no. 51.

6 Translation as in Jones and Penny 1983, p. 5. On the letter, addressed to Piero Soderini, *Gonfaloniere* of the Florentine Republic, and now lost, see Golzio 1936, pp. 9–10, and Shearman 2003, vol. 2, pp. 1457–62, who dismisses it as spurious. That view has been cautiously rejected by several recent scholars and the one-time existence of such a letter is again accorded serious weight; see Reiss 2005, p. 328, note 77, for a synopsis.

7 On Raphael's movements in this period, see Jones and Penny 1983, pp. 5 and 21 (with slightly inconsistent accounts of his repeated presence in Urbino during the years 1504–7), Shearman 1996, and Reiss 2005. The artist's enduring ties to the city of his birth continued even after his permanent move to Rome, as discussed most recently in Urbino 2009.

8 The painting may be one of the two Madonnas that Raphael, according to Vasari, painted for Guidobaldo da Montefeltro "in his second manner" during one of his return visits to Urbino from Florence (V–M, vol. 4, p. 322). It has been suggested by Becherucci 1968, vol. 1, p. 76, that the work was painted for Guidobaldo's sister Giovanna Feltria della Rovere, the "Prefetessa" (author of the purported letter of introduction Raphael bore with him to Florence; see note 6 above), who figures later in this essay. San Bernardino is the mortuary chapel of Guidobaldo and Federico da Montefeltro.

9 The argument of Sergio Ortolani, summarized by Dussler 1971, p. 64.

10 For the early copy (Madrid, Museo Nacional del Prado), see Paris 2012, pp. 234–39, cat. no. 77. This compositional device in the Borghese portrait is often said to derive from Leonardo (i.e. Woods-Marsden 2001, p. 79), but a compelling alternative source is to be found in fifteenth-century Netherlandish portraits (e.g., Hans Memling's 1487 portrait of Benedetto Portinari, Florence, Galleria degli Uffizi, a work often discussed in this connection, most recently by Nuttall 2014, pp. 33–34). Examples of such Netherlandish portraits would have been known to Raphael.

11 See Cordellier and Py 1992, 58–60, cat. no. 47.

12 Pervasive similarities notwithstanding, not all scholars concur that the drawing is a study for the *Portrait of a Lady with a Unicorn*. Cordellier and Py 1992, p. 60, and Oberhuber 1999, p. 80, relate it to the Borghese portrait. However, Tom Henry (in London 2004, p. 176, cat. no. 52) notes the similarities to both the *Maddalena Strozzi* and the *Portrait of a Lady with a Unicorn* and refrains from expressly connecting the drawing to either or categorizing it as a preparatory study for a painted portrait, commenting that "it may be the case that this drawing was not intended as a portrait of a particular person, but represents Raphael's investigation of the formal possibilities of Leonardo's compositional developments." More recently, Talvacchia 2007, p. 60, implies that the drawing is connected with the portrait of Maddalena Strozzi, though with no accounting of the columns.

13 A somewhat analogous situation obtains in the case of the portrait of Doña Isabel de Requesens y Enríquez de Cardona-Anglesola (Paris, Musée du Louvre, formerly believed to depict Joanna of Aragon; for the correct identification of the sitter, see Fritz 1997), wife of the Viceroy of Naples, a sitter Raphael had never seen—though he did dispatch one of his assistants, probably Giulio Romano, to Naples to make a portrait drawing of her on which the painted portrait was based. Scholars disagree on the nature and extent of Raphael's involvement in the painting's execution. For the

most recent discussion, see Tom Henry and Paul Joannides, in Madrid and Paris 2012, pp. 275–78, cat. no. 76.

14 Two notable exceptions are the portraits of Bindo Altoviti (Washington, DC, National Gallery of Art) and the above-cited Doña Isabel de Requesens y Enríquez de Cardona-Anglesola. Jones and Penny 1983, p. 166, observe that blonde hair was both rare and desirable in Italy in this period, a point made again later in this essay. The relative rarity of blonde hair in contemporaneous and later portraits of actual sitters is in contrast to its frequency in portraits of *Belle*—imagined, idealized beautiful women—who are often portrayed with flowing golden tresses (though it should be noted that women in mid-fifteenth-century Florentine portraits such as those by Pollaiuolo are often blonde; see Milan 2014, pp. 240–52, cat. nos. 24–27).

15 With regard to late fifteenth-century Florentine female portraits, Weppelmann 2011, p. 67, has characterized the expressionless features of many sitters and remarked that "in the representation of the subject's physiognomy, artists were less concerned with producing a precise likeness than with adapting the subject's individual appearance to a codified type . . . what was considered important was not her depiction *dal naturale*, but rather the exaltation of her appearance as the physical embodiment of moral perfection." That paradigm shifts in the sixteenth century, when female portraits assume a greater degree of individual characterization and interiority, but such observations are nonetheless profitably applied to the *Portrait of a Lady with a Unicorn*.

16 Similar distinctive and unusual tall conical spires also crown the towers of the Palazzo Ducale in Urbino and the campanile of San Bernardino as portrayed by Raphael in the background of the *Small Cowper Madonna*.

17 Another instance of Raphael using recognizable architectural monuments to signal a connection with a specific place is a drawing of Saint Jerome for an unknown project (ca. 1504), which includes in the background a meticulously rendered cityscape of Perugia (Oxford, Ashmolean Museum, inv. no. WA1846.10). The distant blue mountains in the background of the *Small Cowper Madonna* (see fig. 1)—by inference, the landscape and hills around Urbino—are also similar to the terrain seen in the distance in the *Lady with a Unicorn*.

18 A scabrous pasquinade composed during Paul III's pontificate (1541) referred to the then-deceased Giulia as "quella porca Giulia sorella tua" (your sister the slut) who lay under Alexander VI (document published in Romei and Rosini 2012, p. 355).

19 *Pace* Bradford 2004, p. 35, who disputes the view that Alexander VI was Laura's biological father. The Florentine

jurist and future cardinal Lorenzo Pucci repeatedly referred to Laura as the pope's daughter in a letter written in December 1493 to his brother recapitulating a conversation he had had with her uncle Cardinal Farnese. In it he reports that he said to the cardinal, "I believe that this child [Laura] is the Pope's daughter, just as Lucretia is, and your Highness's niece" (Gregorovius ed. Goldscheider, p. 42). According to Gregorovius, "the child officially passed as that of [Giulia's] husband, Orsini, although in reality the pope was its father" (ibid., p. 41).

20 Alexander VI's particular interest in Laura Orsini is attested in documents pertaining to her: for example, a motu proprio of 1 March 1502 ordering payment of 2,000 ducats on her behalf from the Camera Apostolica upon the dissolution of her nuptial agreement with Federico Farnese, which had been drawn up on 2 April 1499 (document published in Romei and Rosini 2012, pp. 226; see pp. 210–18 for the original nuptial contract). This was in fact the third matrimonial scheme that the pope orchestrated for Laura. The year after her birth, in 1493, she was betrothed to Astorgio Manfredi, lord of Faenza. That was followed by a hoped-for, vastly more advantageous union with Giuliano de' Medici (1479–1516), son of Lorenzo il Magnifico and younger brother of the future Pope Leo X, which never materialized (see Fornari 1995, pp. 95–99). Finally, in 1499, came the eventually dissolved agreement with Federico Farnese.

21 V–M, vol. 3, p. 499, a story repeated by the nineteenth-century historians Gregorovius and Pompeo Litta but refuted by, inter alia, Pastor, vol. 6, pp. 174–75. However, a recently identified fragment of the detached original that came from the Chigi Collection, and a seventeenth-century copy of the entire composition by Pietro Facchetti, appear to confirm that the work—and presumably the anecdote behind it—were not fictitious inventions. On these discoveries see Nucciarelli 2006, who proposes that the offending image was concealed behind a curtain and eventually removed by Alexander VII Chigi.

22 Ferrara 2002; Fioravanti Baraldi 2002; Williams 2012.

23 Jones and Penny 1983, p. 166.

24 "She is of middle height and graceful in form, her face is rather long, the nose well cut, hair golden, eyes of no special color . . . ;" account of Niccolò Cagnolo of Parma, translated and quoted in Pastor, vol. 5, p. 400. A description of Lucrezia's arrival in Ferrara in 1502 dwelled on her striking blonde hair, loosely held in a spectacular jeweled net (Williams 2012, p. 70.) Two purported portraits of Lucrezia, one a Saint Catherine by Pinturicchio in the Borgia apartments in the Vatican, and another by Bartolomeo Veneto believed to

represent Lucrezia as Flora—though dubious as literal portraits—corroborate the written descriptions in showing a woman with long, flowing blonde tresses. Lorenzo Pucci's adulatory description of Laura's mother, Giulia Farnese, suggests, though less unequivocally, that she, too, had blonde hair: "She let her hair down before me and had it dressed; it reached down to her feet; never have I seen anything like it; she has the most beautiful hair. She wore a headdress of fine linen, and over it a sort of net, light as air, with gold threads woven in it. In truth it shone like the sun!" (quoted in Gregorovius ed. Goldscheider 1948, p. 70).

25 Davide Gasparotto, in Padua 2013, pp. 144–45, cat. no. 2.3; repr. p. 131. In one of his poems, Bembo professed to being "caught in the beauty of Lucrezia's blonde hair" (Bradford 2004, p. 189).

26 The diary of Johann Burchard, Alexander VI's Master of Ceremonies, captures something of the jocularity and irreverence of the extended papal household; see, for instance, his description of various events of May 1496 (Burchard ed. Glaser 1921, pp. 85–88). It is known that Giulia Farnese was fond of and attached to both Lucrezia Borgia and her stepmother-in-law, Adriana de Mila. Lucrezia returned the affection; in a letter of June 1494 to her father she referred to "the Lady whom I hold as my mother [Adriana] and Madonna Julia whom I hold as my sister" (translated and quoted in Bradford 2004, p. 41).

27 The unicorn's presence is presumably the source of the baseless identification of Raphael's sitter as Giulia Farnese occasionally encountered in popular literature. Domenichino's fresco of ca. 1604 of a maiden with a unicorn in the Palazzo Farnese in Rome, and an earlier, anonymous sixteenth-century painting (sometimes attributed to Luca Longhi) of the same subject (Rome, Museum of Castel Sant'Angelo), have also both been identified as portraits of Giulia, as have the kneeling woman pointing to the possessed boy in the foreground of Raphael's *Transfiguration* and one of the female personifications on the tomb of Paul III in Saint Peter's— none on any particular authority.

28 The tomb was erected in San Giovanni Battista, Isola Bisentina, in 1449, and later moved to Santi Giacomo e Cristoforo. For an illustration see Fornari 1995, facing p. 20.

29 For example, the ceiling and frieze of the Sala del Perseo by Perino del Vaga and his workshop in the Pauline apartments in Castel Sant'Angelo, ca. 1546–47 (Parma Armani 1986, figs. 268 and 269).

30 That imagery also includes paired columns, raising the possibility that the more literal appearance of these architectural elements in the Borghese portrait carried some meaning or personal reference; see further note 56 below. In a fresco in another of the rooms at Carbognano, a unicorn prepares to dip its horn into a fountain (Fornari 1995, facing p. 148). Neither of these anonymous decorations is dated. The ceiling at Vasanello is believed to have been painted around 1505–6, and the apartments at Carbognano probably between 1515 and 1522 (for the dating see Fornari 1995, p. 230; and for a passing discussion of the decorations, Luzi and Rossini 2013.).

31 Leonardo da Vinci ed. MacCurdy 1955, p. 1079.

32 Ripa 1603, p. 505: "Virginita: Giovanetta, la quale accarezzi on le mani vn'Alicorno, perche, come alcuni scriuono, questo animale no si lascia prendere se non per mano di Vergine."

33 Berlin and New York 2011, pp. 231–32, 279–81, cat. nos. 87 and 115, respectively. On the medal, see also Syson 1997, pp. 50–51, and Washington 2001, pp. 118–20, cat. no. 7. The unicorn also appears on the reverse of a medal of Lodovica Tornabuoni, for which see Washington 2001, pp. 127–29, cat. no. 10. The pendant worn by Maddalena Strozzi in Raphael's portrait incorporates a unicorn (see fig. 2).

34 The iconography of Petrarch's *Triumph of Chastity* is discussed by Kirkham 2001, p. 57 (without reference to the Battista Sforza portrait). The subject was also treated by Jacopo del Sellaio in a panel of ca. 1480–85 now in the Museo Bandini, Fiesole; see fig. 20 in this catalogue.

35 The contract was drawn up on 2 (or 9?) November 1505 in the presence of the pope and several cardinals, and notarized by Camillo Benimbene. This and other pertinent documents relating to the marriage are published in Romei and Rosini 2012, pp. 233–250. See also Lowe 1993, p. 168, who gives the date of the *sponsalia* (the official ceremony sealing and notarizing the contractual agreement) as 9 November 1505, and Fornari 1995, pp. 224–25. At the same moment Pope Julius II negotiated three other politically advantageous marriages for his della Rovere relations: those of another nephew, Francesco Maria della Rovere, future duke of Urbino, to Eleonora Gonzaga, also in November 1505 (the contract also notarized by Benimbene); his niece Lucrezia della Rovere to Marcantonio Colonna in July 1506; and his daughter, Felice della Rovere, to Gian Giordano Orsini in the same year. See Lowe 1993, pp. 168–69; Verstegen 2007, p. xx; for Felice della Rovere, see Murphy 2005.

36 Events recorded some decades later by the priest Don Lando Leoncini, who follows this account of the November 1505 wedding ceremony in the Sala dei Pontefici with reference to a nuptial celebration in the house of Cardinal Raffaelle Riario on 6 June 1506 (document published in Romei and Rosini 2012, p. 33).

37 For Cardinal Alessandro in particular, the betrothal signified that "he was ready to hitch his wagon to the new pope," and that he was now a "proper, loyal follower" (Fornari 1995, pp. 221–22).

38 Verstegen 2007, p. xx.

39 At the time of this marriage, the della Rovere were "rulers-in-waiting" to the duchy of Urbino, Francesco Maria della Rovere having been designated heir in 1504 (at the pope's instigation) by the childless Guidobaldo da Montefeltro, whom he would succeed as duke in 1508.

40 *Scudo accolato* with blue lilies on a gold ground (Farnese), and red-and-white bendy sinister beneath a red rose (Orsini). Female patronage is often signaled, as here, by the presence of such a *scudo accolato*, which combines the stemma of a woman's father and husband. On this see Valone 2001, p. 322, with reference to the impaled arms of Vittoria della Tolfa in the Chapel of the Ascension in Santa Maria in Aracoeli, Rome (which coincidentally, like that of Giulia Farnese, includes the Orsini stemma).

41 For a reproduction, see Luzi and Rosini 2013, p. 11, fig. 9.

42 An analogous instance of a sitter attired in contemporary dress of heraldic colors is Bronzino's portrait of Lodovico Capponi (New York, Frick Collection), who is handsomely clad in the black and white of the Capponi stemma.

43 The reason for the transformation of the original dog (?) into the unicorn is unknown (both are conventional symbols of the female virtues of fidelity and chastity, respectively), but it should be reiterated in this connection that Laura Orsini is one person whose betrothal arrangements were contracted and dissolved multiple times before she finally married Niccolò della Rovere in 1505—a circumstance that conceivably necessitated changing the iconography of her nuptial portrait to emphasize not just fidelity (an attribute of a faithful wife) but purity—a virtue desired in a prospective bride. That said, it might be worth questioning the identification of the animal imaged in X-rays as a dog. The underlying image in the Borghese portrait could conceivably be interpreted as a variety of beasts, including a less successfully represented unicorn, or perhaps a bear cub (the Orsini heraldic beast)—a detail that was later repainted either to impart a different attribute to the sitter, or because it was damaged or otherwise judged deficient. The ungainly animal in the *Holy Family with the Lamb* of ca. 1507 (Madrid, Museo Nacional de Prado) demonstrates that Raphael at this date was not always a consummate animal painter.

44 Letter published in Romei and Rosini 2012, p. 277. The missive accompanied a panegyric Tebaldeo wrote praising Laura, rather unimaginatively, as the new laurel that took root

in a new age whose food was acorns (the fruit of the oak tree, symbol of the della Rovere).

45 Woods-Marsden 2001, p. 65; Fahy 2008 offers a nuanced definition of marriage portraits and the range of nuptial-related events they conceivably commemorate, while confirming that "many marriage portraits appear to have been made about the time of the marriage ceremonies" (p. 18). This impetus pertains in the case of those portraits made to record the features of a daughter whose marriage to a distant spouse would take her away from her family and natal city; in Fahy's analysis, such works can still be broadly considered marriage portraits. Cordellier and Py 1992, p. 60, offer a list of prominent but exclusively Florentine women who were married in the period 1505–6 as a pool from which a possible candidate for the sitter represented in the Borghese portrait might be found.

46 Ranuccio I Farnese, Duke of Parma (1569–1622), married Margherita Aldobrandini (1588–1646) on 7 May 1600, a political alliance intended to reconcile and ally the two families. The *Portrait of a Lady with a Unicorn* is first documented in the Aldobrandini collection in 1623, the year after Ranuccio Farnese's death.

47 The gold clasp suggests that this item of her costume expressly represents the type of "particularly extravagant girdle" associated with betrothal and marriage. For this accoutrement, see the discussion by Jacqueline Marie Musacchio, in New York and Fort Worth 2008, p. 105, under cat. no. 36a. Gold hair ornaments, sometimes embellished with pearls or other jewels, were also often part of a dowry (as is presumably the case with the one worn by the sitter in Raphael's portrait), as discussed by Brandi 2014.

48 As expressly stated by Oberhuber 1999, p. 80, where the work is called a "bridal portrait," though without further discussion. This received wisdom has been voiced in the literature, but why this is so, or which of the various types or categories of "bridal portraits" it might be, has never been substantiated or investigated.

49 Woods-Marsden 2001, p. 64, who further stresses that "the jewels adorning the bride were read as visible proof of the size of her dowry" (ibid., p. 67). Such jewels could be given by the bride's family as part of her dowry, or presented as gifts to her by the groom; see Crabb 2000, p. 91, for a first-hand account of this practice recorded in letters written by Alessandra Strozzi about her daughter and future son-in-law in 1447; and Brandi 2014. Sumptuary laws in Florence and elsewhere prohibited women from wearing such conspicuous jewels within a few years of marriage. The fact that the sitter wears a marriage girdle and the type of expensive jewels

associated with a dowry makes it unlikely that the *Portrait of a Lady with a Unicorn* is another type of marriage-related portrait—a depiction of an otherwise unknown prospective bride for the consideration of her potential husband and in-laws.

50 Brandi 2014, p. 115.

51 Document published in Romei and Rosini 2012, p. 251. The debt was incurred as the result of an unpaid loan to Laura's grandmother Adriana de Mila, who had died two months earlier, and which Laura, as her designated heir, inherited. Also listed is another gold chain with enamel links.

52 The knotted chain is similar to that worn by the unknown sitter in the portrait known as *La Muta*, who may represent someone from the court of Urbino (although Raphael's authorship and the identity of the sitter are both subjects of debate).

53 Document published in Romei and Rosini 2012, p. 254, which refers to a jewel box and other furnishings valued at 3,000 ducati, part of Laura's inheritance from Orsino Orsini and Adriana de Mila. The high valuation indicates that actual jewels, and not just the casket for holding them, were among the goods (*beni mobili*).

Examination of the pendant under magnification seems at a glance to reveal the presence of the Orsini rose in the center of the ruby, though this is presumably a trick of the eye. The enamel wisps of the pendant loosely resemble the fleurs-de-lis embellishments at the center of the neckline of the gown worn by Elisabetta Gonzaga, Duchess of Urbino, in a portrait ascribed to Raphael (Florence, Galleria degli Uffizi).

54 A similar attention to the material properties of gems and jewels is evident in Raphael's 1511 portrait of Pope Julius II, the uncle of Laura Orsini's husband (London, National Gallery), as noted by Tom Henry, in London 2004, p. 174, under no. 51. For the symbolic significance of these jewels, see Partridge and Starn 1980, pp. 60–61, and Jones and Penny 1983, p. 158.

55 12 June 1506, from Urbino; letter published in Romei and Rosini 2012, p. 253.

56 Meyer zur Cappellen 2001, 1: cat. nos. X-12 (Emilia Pia) and X-13 (Elisabetta Gonzaga), both as rejected attributions. The latter portrait is accepted as an autograph in Urbino 2009, cat. no. 39. Both women were also commemorated in portrait medals by Adriano Fiorentino, for which see Syson 1997, pp. 51–52.

57 Reiss 2005, p. 331, note 109.

58 Ibid., pp. 44–46, posits that a chain of influence from the Prefetessa to Julius may have propelled Raphael to Rome, considering such a scenario more plausible than Vasari's claim that the papal architect Bramante, Raphael's distant relation, provided the introduction to the pope. Verstegen 2007, p. xxii, makes the essential point that "the call of Raphael to Rome cannot be separated from a della Rovere connection." Beyond the scope of this discussion but worth mentioning here are Giovanna Feltria della Rovere's ties to Rome, where she lived for some years as wife of the prefect, Giovanni della Rovere, and where she almost certainly knew Giulia Farnese and Laura Orsini. My thanks to Sheryl Reiss for making this point.

59 In the dedicatory preface to the first book of the *Courtier* (Castiglione ed. Javitch 2002, pp. 13–14).

60 See Syson 2008; New York and Fort Worth 2008, pp. 76–81, 317–19, cat. nos. 9–14 and 146a–b, respectively. Fifteenth-century antecedents include the so-called *Simonetta Vespucci* by Botticelli (Washington 2001, pp. 182–85, cat. no. 28; Berlin and New York 2011, pp. 120–23, cat. nos. 19 and 20). Stefan Weppelmann, in Berlin and New York 2011, p. 123, under cat. nos. 19 and 20, credits these portraits of Simonetta with the "intention of visualizing humanistic formulations of ideal beauty." On sixteenth-century poetic and theoretical constructs of female beauty and their cognates in painting, see the fundamental study by Cropper 1976. See also Vaccaro 2013. As analyzed by Cropper, op. cit., columns were among the inanimate forms construed as an analogue of perfect female beauty. Perhaps the poetic trope that fueled this conceit found some incipient visual expression in the columns framing the sitter in the *Portrait of a Lady with a Unicorn*, and also in the enigmatic paired columns employed by Giulia Farnese, together with the unicorn and the lily, in her personal imagery (see fig. 10).

61 It is not impossible that the artist did journey to Rome at this time; as noted at the beginning of this essay, he traveled frequently during his four years in Florence, and a trip there in this period has been posited. Certainly the Louvre drawing discussed above as a preparatory study for the Borghese portrait (see pl. 4) conveys little impression of having been drawn from life, however.

62 Later in Raphael's career this poetic trope is imputed to him in a letter, probably composed by Castiglione, articulating *una certa idea* (a certain idea) of ideal beauty which, he recounts, is not based on a single beautiful woman, but rather is a synthesis of the best features of many. On this, see Jones and Penny 1983, p. 97 (who endorse the then-prevailing idea that the author of the letter was Pietro Aretino); and Wolk-Simon 2008, p. 45. Castiglione as the author of the letter was proposed by Shearman 2003, vol. 1, pp. 734–41.

63 Petrarch repeatedly mentions Laura's blonde hair in the *Canzoniere*: " . . . the pretty veil that holds her lovely blonde hair in the breeze" (No. 52); "She'd let her gold hair flow free in the breeze . . ." (No. 90); ". . . a flower falling on her lap, some on her golden curls, like pearls set into gold . . ." (No. 126); ". . . let such fine hair of gold flow in the breeze? (No. 159)" (Petrarch ed. Musa 1999, pp. 34, 38, 42, and 55). The poet also refers to his beloved's "fair eyes" p. 38), a designation that aptly applies to the eyes of the sitter in the Borghese portrait, though he is otherwise largely silent on Laura's physical appearance, to the frustration of later poets who attempted to visualize the ideal of beauty she embodied. On this, see Cropper 1976, p. 386. This reticence also characterizes Dante's references to the physical appearance of his beloved, Beatrice, about which he reveals "practically nothing" (Kirkham 2001, p. 51). Petrarch in two of his sonnets refers to a (possibly fictional) lost portrait of Laura by Simone Martini—the poetic if physically absent paradigm for later portraits of beautiful women: see Washington 2001, pp. 204–7, under no. 35; Rubin 2011, pp. 6–7, 17. On the literary poetics of the portrait of Laura, see Cranston 2000, pp. 2–3.

64 Cropper 1976; recapitulated in Williams 2012, p. 97, where these specific traits are enumerated and identified as deriving from a "Petrarchan tradition of love lyrics in which the female beloved is described in these ideal and set terms." Boccaccio embraces and expands on this paradigm in its every detail when describing one of the beautiful women in the pastoral romance *Comedy of the Florentine Nymphs (Comedia delle ninfe fiorentine)* of ca. 1341–42; translation in Kirkham 2001, p. 53.

65 Syson 1997, pp. 49–50; Kirkham 2001, pp. 53–55, discusses the *topos* in Boccaccio.

66 See Cropper 1976; Wolk-Simon 2008, p. 45; Vaccaro 2013; and the essay by Mary Shay-Millea in this volume.

67 Syson 1997, p. 51, has remarked of Renaissance medallic portraits of women that it was of preeminent importance that the subject be portrayed as beautiful; "less important what she actually looked like." A similar idea is articulated by Williams 2012, p. 86, who observes that portraying status and rank, and suggesting exemplary morals, was often more important in portraits of noblewomen than verisimilitude or achieving a "perfect likeness." Such exigencies inform the *Portrait of a Lady with a Unicorn* and help account for the sitter's pleasing yet formalized and somewhat generalized physical aspect.

68 This imperative is articulated by Rubin 2011, p. 5.

69 Here applying the observation of ibid., p. 17, that in later fifteenth-century portraiture "there was a significant crossover between the way that women were judged and remembered as actual people and the ways that they existed as poetic figures."

The Lover Entrapped

My sincere thanks to Esther Bell and Colin Bailey for including my essay in this catalogue and to Sarah Blake McHam and Carmen Bambach.

1 Petrarch trans. Musa 1996, pp. 290–91: "Li occhi sereni et le stellanti ciglia, / la bella bocca angelica di perle / piena et di rose, et di dolce parole / chef anno altrui tremar di meraviglia, / et la fronte, et le chiome ch'a vederle / di state a mezzo di vincono il sole."

2 The inspiration for Petrarch's famous collection of love sonnets was Laura, a beautiful, yet unobtainable, woman Petrarch claimed to have met in the Church of Saint Claire in Avignon on 6 April 1327.

3 Condra 2008, p. 35.

4 For the Italian text see Buonarroti trans. Nims 1998, p. 15: "E più bel c'una rapa; / e' denti bianchi come pastinaca,... e' cape' bianchi e biondi più che porri: / ond'io morrò...."

5 In 1341, after the completion of his first major work, *Africa*, Petrarch became the first poet laureate since antiquity, receiving his laurel crown in Rome.

6 Petrarch trans. Musa 1996, pp. 130–31: "Chen el cielo / so ponno imaginar."

7 Although only five of Raphael's own poems survive, they are all fashioned on Petrarch's *Canzoniere* and address the poet/painter's beloved. See Craven 1994, p. 392: "E (s)face / da bianca neve e rose vivace.... / [e] candida braci...."

8 Washington, National Gallery of Art (1967.6.1.a).

9 Ginevra, like Lucrezia, was praised for her beautiful hands in contemporary poetry. See Landino trans. Chatfield 2008, p. 285: "Est opus in minibus: Palladis extat opus." Leonardo was an apprentice in Verrocchio's workshop during the same years that Andrea del Verrocchio produced Lucrezia Donati's now-lost portrait and his marble *Lady with a Bunch of Flowers*. This may have been Leonardo's inspiration for the inclusion of hands in his *Portrait of Ginevra de' Benci. A Study of Hands* by Leonardo may be a preliminary drawing for Ginevra's portrait. For a complete discussion, see Washington 2001, pp. 148–49.

10 See Walter and Zapperi 2006, p. 38.

11 Washington 2001, pp. 150–51.

12 The Ashmolean drawing (WA1855.83.1) was probably executed during the mid- to late 1470s, while the British Museum version (1860-6-16-98) was drawn ca. 1478–80. See New York 2003, pp. 307–8.

13 Petrarch trans. Musa 1996, pp. 290–91. "Diti schietti soave, a tempo ignudi / consente or voi per arricchirme Amore."

14 Cecilia was likely pregnant with Ludovico Sforza's child at the time the portrait was painted, and Jacqueline Musacchio interpreted the inclusion of the ermine as a reference to her physical state and a talisman for a healthy birth. For a complete discussion, see Musacchio 2001, p. 180.

15 Ludovico was invested with the Order of the Ermine in 1486 by the King of Naples, and was sometimes referred to as "L'Ermellino" (Pedretti 1996). He was also referred to as "Italico Morel, bianco Ermellino" (Italian Moor, white Ermine) in contemporary poetry by Bernardo Bellincioni, who also wrote sonnets in honor of Cecilia's portrait. See Marani 2000, p. 169.

16 Musacchio (Musacchio 2001, p. 175) has suggested the ermine is meant to make the painting a double portrait of Cecilia and Ludovico.

17 Ibid., p. 174. Emil Möller initially made the connection in 1916 and many scholars have since agreed. Möller 1916, pp. 313–26.

18 In 1995, Krystyna Moczulska (Moczulska 1995) was the first to propose a relationship between the myth and the ermine in Cecilia's portrait. Ovid was not the only teller of this myth; variations were also recorded by Antoninus Liberalis, Pausanias, and Homer. For a recent in-depth discussion of the myth, see Bettini 2013.

19 There is archival evidence of Beatrice's jealousy through the Ferrarese ambassador, Giacomo Trotti. In a letter of November 1490 to Beatrice's father, Ercole d'Este, Trotti told the duke that Ludovico did not seem enthusiastic about Beatrice's arrival at court because he had a mistress living at court who was "beautiful like a flower" (bella come un fiore) and pregnant with Ludovico's child. Shell and Sironi 1992, p. 57.

20 The weasel, according to the *Physiologus* (Curley 2009), is impregnated through the mouth and gives birth through her ears, just as the Virgin Mary was believed to conceive through her ear. The unicorn was also interpreted Christologically in the *Physiologus*. Christ entered the womb of the Virgin and was "loved like the son of unicorns." Like the unicorn, Christ was unable to be captured by the devil and could only be contained in his virgin mother's womb. See ibid., pp. 97–99. David Alan Brown and others have associated

Mary's miraculous pregnancy with the covering of the ears of young women in Renaissance paintings in order to protect their chastity.

21 Fournival trans. Beer 2000, pp. 11–12.

22 The Pierpont Morgan Library, New York, MS M.459, fol. 10v.

23 Fournival trans. Beer 2000, pp. 21, fol. 13r.

24 Richter 1939, p. 1234: "L'ermellino per la sua moderàtia nō màgia se non vna sola volt ail dì, e prima si lascia pigliare dai cacciatori che volere fugire nella infangata tana, per nō maculare la sua giētilezza." Leonardo also drew an *Allegory of the Ermine*, now in the Fitzwilliam Museum in Cambridge.

25 Ibid., 1232: "Il liocorno overo vnicorno per la sua intêperàza e nō sapersi uî ciere per lo diletto che à delle donzelle dimētica la sua ferocità e saluatichezza; ponēdo da câto ogni sospetto va alla sedente donzella e se le adormēta in grēbo, e i cacciatori in tal modo lo pigliano."

26 The dish, now in the Metropolitan Museum of Art, New York (46.85.30), includes the arms of Matthias Corvinus, the King of Hungary, and his second wife, Beatrix of Aragon. The plate was likely part of a larger service produced in Pesaro.

27 Now in the North Carolina Museum of Art (GL.60.17.23).

Portrait of a Lady with a Unicorn

1 Meyer zur Capellen 2001, p. 290. See also Giacomo 1996.

Bibliography

Becherucci 1968

Becherucci, Luisa. "Raffaello e la pittura." In *Raffaello: l'opera, le fonti la fortuna*, edited by Mario Salmi, 7–197. 2 vols. Novara: Istituto Geografico de Agostini S.p.A., 1968.

Berlin and New York 2011

The Renaissance Portrait: From Donatello to Bellini. Edited by Keith Christiansen and Stefan Weppelmann. New York: The Metropolitan Museum of Art, in association with Yale University Press, 2011. An exhibition catalogue.

Bernini et al. 1984

Bernini, Dante. *Aspetti dell'arte a Roma Prima e dopo Raffaello: Roma, Palazzo Venezia*. Rome: De Luca, 1984. An exhibition catalogue.

Bettini 2013

Bettini, Maurizio. *Women and Weasels: Mythologies of Birth in Ancient Greece and Rome*. Chicago: University of Chicago Press, 2013.

Bon Valsassina 1984

Bon Valsassina, Caterina. "Raffaello Sanzio. Rittratto di giovane donna con unicorno." In *Raffaello nelle raccolte Borghese*, edited by Dante Bernini, Sara Staccioli, and Giulia Barberini, 20–28. Rome: Arno e Tevere, 1984. An exhibition catalogue.

Boskovits and Brown 2003

Boskovits, Miklós, and David Alan Brown, eds. *Italian Paintings of the Fifteenth Century: The Collections of the National Gallery of Art*. Washington, DC: National Gallery of Art, 2003. Distributed by Oxford University Press.

Bradford 2004

Bradford, Sarah. *Lucrezia Borgia: Life, Love and Death in Renaissance Italy*. New York: Viking, 2004.

Brandi 2014

Brandi, Elisa Tosi. "Fashion, Art, History, and Society in Portraits of Women by Piero Pollaiuolo." In *Antonio and Piero del Pollaiuolo, "Silver and Gold, Painting and Bronze..."* edited by Andrea di Lorenzo and Aldo Galli, 103–17. Milan: Skira, 2014.

Buonarotti trans. Nims 1998

Buonarotti, Michaelangelo. *The Complete Poems of Michelangelo*. Translated by John Frederick Nims. Chicago: The University of Chicago Press, 1998.

Burchard ed. Glaser, 1921

Burchard, Johann. *Pope Alexander VI and His Court: Extracts from the Latin Diary of Johannes Burchardus*. Edited by F. L. Glaser. New York: N. L. Brown, 1921.

Camesasca 1956

Camesasca, Ettore. *Tutta la pittura di Raffaello*. Vol. 1. Milan: Rizzoli, 1956.

Cantalamessa 1916

Cantalamessa, Giulio. "Un ritratto femminile nella Galleria Borghese." *Rassegna d'Arte Antica e Moderna* 16, no. 9 (1916): 187–191.

Castiglione ed. Javitch 2002

Castiglione, Baldesar. *The Book of the Courtier: The Singleton Translation*. Edited by Daniel Javitch. Translated by Charles Singleton. New York: W. W. Norton & Co., 2002.

Condra 2008

Condra, Jill, ed. *The Greenwood Encyclopedia of Clothing through World History*. Vol. 2, *1501–1800*. Westport, CT: Greenwood Press, 2008.

Cordellier and Py 1992

Cordellier, Dominique, and Bernadette Py. *Raphael, son atelier, ses copistes*. Musée du Louvre, Musée d'Orsay, Département des Arts graphiques, Inventaire général des dessins italiens. Vol. 5. Paris: Réunion des Musées Nationaux, 1992.

Crabb 2000

Crabb, Ann. *The Strozzi of Florence: Widowhood and Family Solidarity in the Renaissance*. Ann Arbor: University of Michigan Press, 2000.

Cranston 2000

Cranston, Jodi. *The Poetics of Portraiture in the Italian Renaissance*. New York: Cambridge University Press, 2000.

Craven 1994

Craven, Jennifer. "*Ut Pictura Poesis*: A New Reading of Raphael's Portrait of *La Fornarina* as a Petrarchan Allegory of Painting, Fame, and Desire." *Word & Image* 10, no. 4 (1994): 371–94.

Cropper 1976

Cropper, Elizabeth. "On Beautiful Women, Parmigianino, *Petrarchismo*, and the Vernacular Style." *The Art Bulletin* 58 no. 3 (September 1976): 374–94.

Curley 2009

Curley, Michael J., trans. *Physiologus, a Medieval Book of Nature Lore*. Chicago: University of Chicago Press, 2009. First published 1979 by University of Texas.

Della Pergola 1959

Della Pergola, Paola. *Galleria Borghese: I dipinti*. 2 vols. Rome: Istituto poligrafico della Stato, 1959.

De Rinaldis 1936

De Rinaldis, Aldo. "Il restauro del quadro n. 371 della Galleria Borghese." *Bollettino d'Arte* 30 (1936): 122–29.

De Vecchi 1966

De Vecchi, Pierluigi. *L'opera complete di Raffaello*. Milan: Rizzoli Editore, 1966.

De Vecchi 1995

De Vecchi, Pierluigi. *Raffaello: La mimesi, l'armonia e l'invenzione*. Florence: Edizioni d'arte il Fiorino, 1995.

Dussler 1971

Dussler, Luitpold. *Raphael: A Critical Catalogue of His Pictures, Wall-Paintings and Tapestries*. Translated by Sebastian Cruft. London: Phaidon, 1971. First published 1966 by R. Bruckmann KG.

Fahy 2008

Fahy, Everett. "The Marriage Portrait in the Renaissance, or Some Women Named Ginevra." In *Art and Love in Renaissance Italy*, edited by Andrea Bayer, 17–27. New York: The Metropolitan Museum of Art, in association with Yale University Press, 2008. An exhibition catalogue.

Ferino Pagden and Zancan 1989

Ferino Pagden, Sylvia, and Maria Antonietta Zancan. *Raffaello: Catalogo complete dei dipinti*. Florence: Cantini Editore, 1989.

Ferrara 2002

Lucrezia Borgia. Edited by Laura Laureati. Ferrara: Palazzo Bonacossi, in association with Ferrara Arte, 2002. An exhibition catalogue.

Fioravanti Baraldi 2002

Fioravanti Baraldi, Anna Maria. *Lucrezia Borgia: La beltà, la virtù, la fama onesta*. Ferrara: G. Corbo, 2002.

Fornari 1995

Fornari, Carlo. *Giulia Farnese: Una donna schiava della propria bellezza*. Parma: Silva, 1995.

Fournival trans. Beer 2000

Fournival, Richard de. *Master Richard's Bestiary of Love and Response*. Translated by Jeanette Beer. West Lafayette, IN: Purdue University Press, 2000.

Freedman 1989

Freedman, Luba. "Raphael's Perception of the Mona Lisa." *Gazette des Beaux-Arts*, 7th series, 114 (1989): 169–82.

Fritz 1997

Fritz, Michael P. *Giulio Romano et Raphael: La vice-reine de Naples*. Paris: Réunion des Musées Nationaux, 1997.

Giacomo 1996

Giacomo, Lia di. "I Cecconi rincipi. Una famiglia di restauroatori romani tra Ottocento e Novecento alla Galleria Borghese." *Kermes arte e tecnica del restauro* (May–August 1996): 33–36.

Goffen 2002

Goffen, Rona. *Renaissance Rivals: Michelangelo, Leonardo, Raphael, Titian*. New Haven: Yale University Press, 2002.

Golzio 1936

Golzio, Vincenzo. *Raffaello nei documenti, nelle testimonianze dei contemporanei e nella letteratura del suo secolo*. Vatican City: Libreria Editrice Vaticana, 1936.

Gregorovius ed. Goldscheider 1948

Gregorovius, Ferdinand. *Lucrezia Borgia: A Chapter from the Morals of the Italian Renaissance*. Edited by Ludwig Goldscheider. London: Phaidon Press, 1948. First published 1874.

Herrmann Fiore 1992

Herrmann Fiore, Kristina. "Ritratto di dama con liocorno." In *Raffaello e Dante*, edited by Corrado Gizzi, 262–63. Milan: Edizioni Charta S.r.l., 1992.

Jones and Penny 1983

Jones, Roger, and Nicholas Penny. *Raphael*. New Haven: Yale University Press, 1983.

Kirkham 2001

Kirkham, Victoria. "Poetic Ideals of Love and Beauty." In *Virtue and Beauty: Leonardo's "Ginevra de' Benci" and Renaissance Portraits of Women*, edited by David Alan Brown, 49–61. Washington, DC: National Gallery of Art, in association with Princeton University Press, 2001. An exhibition catalogue.

Landino trans. Chatfield 2008

Landino, Cristoforo. *Poems*. Translated by Mary P. Chatfield. Cambridge, MA: Harvard University Press, 2008.

Leonardo da Vinci ed. MacCurdy 1955

Leonardo da Vinci. *The Notebooks of Leonardo da Vinci*. Edited and translated by Edward MacCurdy. New York: G. Braziller, 1955.

London 2004

Raphael: From Urbino to Rome. By Hugo Chapman, Tom Henry and Carol Plazzotta. London: National Gallery, 2004. An exhibition catalogue.

Longhi 1928

Longhi, Roberto. *Precisioni nelle gallerie italiane: La Regia Galleria Borghese*. Rome, 1928.

Lowe 1993

Lowe, K. J. P. *Church and Politics in Renaissance Italy: The Life and Career of Cardinal Francesco Soderini, 1453–1524*. New York: Cambridge University Press, 1993. Also in a 2002 edition, Cambridge University Press.

Luzi and Rosini 2013

Luzi, Romualdo, and Patrizia Rosini. *Il volto di Giulia Farnese, un mistero infinito*. Banca Dati "Nuovo Rinascimento," 2013. http://www.academia.edu/7991345/Il_volto_di_Giulia_Farnese_un_mistero_infinito; http://www.nuovorinascimento.org/n-rinasc/saggi/pdf/luzi/volto.pdf

Madrid and Paris 2012

Late Raphael. Edited by Tom Henry and Paul Joannides. New York: Thames & Hudson, 2013. First published 2012 by Museo Nacional del Prado. An exhibition catalogue.

Mann 1998

Mann, Nicholas. "Petrarch and Portraits." In *Image of the Individual: Portraits in the Renaissance*, edited by Nicholas Mann and Luke Syson, 15–21. London: British Museum Press for the Trustees of the British Museum, 1998.

Marani 2000

Marani, Pietro C. *Leonardo da Vinci: The Complete Paintings*. New York: Harry N. Abrams, 2000.

Meyer zur Capellen 1996

Meyer zur Capellen, Jürg. *Raphael in Florence*. Translated by Stefan B. Polter. London: Azimuth Editions, 1996.

Meyer zur Capellen 2001

Meyer zur Capellen, Jürg. *Raphael: A Critical Catalogue of His Paintings*. Vol. 1, *The Beginnings in Umbria and Florence, ca. 1500–1508*. Translated and edited by Stefan B. Polter. Landshut: Arcos, 2001.

Milan 2014

Antonio and Piero del Pollaiuolo, "Silver and Gold, Painting and Bronze..." Edited by Andrea di Lorenzo and Aldo Galli. Milan: Skira, 2014. An exhibition catalogue.

Moczulska 1995

Moczulska, Krystyna. "Najpiekniejsza Gallerani i najdoskonalsza Galen w portrecie namalowanym przez Leonarda Da Vinci." *Folia Historiae Artium*, n.s., 1 (1995): 55–86.

Möller 1916

Möller, Emil. "Leonardos bildnis der Cecilia Gallerani in der Galerie des Fürsten Czartoryski in Krakau." *Monatshefte für Kunstwissenschaft* 9 (1916): 313–26.

Morelli 1874

Morelli, Giovanni (J. Lermolieff). "Die Galarien Roms: Ein kritischer Versuch I: Die Galerie Borghese." *Zeitschrift für Bildende Kunst* 9 (1874): 1–11.

Murphy 2005

Murphy, Caroline P. *The Pope's Daughter: The Extraordinary Life of Felice della Rovere*. New York: Oxford University Press, 2005.

Musacchio 2001

Musacchio, Jacqueline. "Weasels and Pregnancy in Renaissance Italy." *Renaissance Studies* 15, no. 2 (June 2001): 172–87.

New York 2003

Leonardo da Vinci: Master Draftsman. Edited by Carmen Bambach. New York: The Metropolitan Museum of Art, 2003. An exhibition catalogue.

New York and Fort Worth 2008

Art and Love in Renaissance Italy. Edited by Andrea Bayer. New York: The Metropolitan Museum of Art, in association with Yale University Press, 2008. An exhibition catalogue.

Nucciarelli 2006

Nucciarelli, Franco Ivan. *Pinturicchio: il Bambin Gesù delle mani*. Perugia: Quattroemme: Fondazione Guglielmo Giordano, 2006.

Nuttall 2014

Nuttall, Paula. "Flanders, Florence, and Renaissance Painting: Relationships and Responses." In *Face to Face: Flanders, Florence, and Renaissance Painting*, by Paula Nuttall, 14–51. San Marino, CA: Huntington Library Press, 2013. An exhibition catalogue.

Oberhuber 1999

Oberhuber, Konrad. *Raphael: The Paintings*. New York: Prestel, 1999.

Ortolani 1942

Ortolani, Sergio. *Raffaello*. Bergamo: Instituto Italiano d'Arti Grafiche, 1942.

Padua 2013

Pietro Bembo e l'invenzione del Rinascimento. Edited by Guido Beltramini, Davide Gasparotto and Adolfo Tura. Venice: Marsilio, 2013. An exhibition catalogue.

Paris 2012

La Sainte Anne: l'ultime chef-d'oeuvre de Léonard de Vinci. Edited by Vincent Delieuvin. Paris: Musée du Louvre, 2012. An exhibition catalogue.

Parma Armani 1986

Parma Armani, Elena. *Perin del Vaga, l'anello mancante: Studi sul manierismo*. Genova: Sagep, 1986.

Partridge and Starn 1980

Partridge, Loren, and Randolph Starn. *A Renaissance Likeness: Art and Culture in Raphael's "Julius II."* Berkeley: University of California Press, 1980.

Pastor

Pastor, Ludwig von. *The History of the Popes from the Close of the Middle Ages. Drawn from the Secret Archives of the Vatican and Other Original Sources*. 3rd ed. Edited by Frederick Ignatius Antrobus et al. 40 vols. London: Kegan Paul, 1901–33. Multiple US and English editions, some of which are digitally accessible online.

Pedretti 1996

Pedretti, Carlo. "Quella puttana di Leonardo." *Achademia Leonardi Vinci* 9 (1996): 121–39.

Petrarch trans. Musa 1996

Petrarch. *The Canzoniere*. Translated by Mark Musa. Bloomington: Indiana University Press, 1996.

Petrarch ed. Musa 1999

Petrarch. *Selections from the Canzoniere and Other Works*. Edited and translated by Mark Musa. New York: Oxford University Press, 1999. First published 1985 by Oxford University Press.

Reiss 2005

Reiss, Sheryl E. "Raphael and His Patrons: From the Court of Urbino to the Curia and Rome." In *The Cambridge Companion to Raphael*, edited by Marcia B. Hall, 36–55. New York: Cambridge University Press, 2005.

Richter 1939

Richter, Jean Paul. *The Literary Works of Leonardo da Vinci.* New York: Oxford University Press, 1939.

Ripa 1603

Ripa, Cesare. *Iconologia. Overo descrittione di diverse imagini cavate dall'antichita, & di propria inventione.* Rome: Appresso Lepido Facij., 1603. Reprints issued by Hildesheim in 1970 and 1984.

Rome 2006

Raffaello: da Firenze a Roma. Edited by Anna Coliva. Milan: Skira, 2006. An exhibition catalogue.

Romei and Rosini 2012

Romei, Danilo, and Patrizia Rosini. *Regesto dei documenti di Giulia Farnese.* Raleigh, NC: Lulu.com, 2012.

Rubin 2011

Rubin, Patricia. "Understanding Renaissance Portraiture." In *The Renaissance Portrait: From Donatello to Bellini*, edited by Keith Christiansen and Stefan Weppelmann, 2–25. New York: The Metropolitan Museum of Art, in association with Yale University Press, 2011. An exhibition catalogue.

Shearman 1996

Shearman, John. "On Raphael's Chronology 1503–1508." In *Ars naturam adiuvans: Festschrift für Matthias Winner: zum 11 Marz 1996*, edited by Victoria von Flemming and Sebastian Schütze, 201–7. Mainz am Rhein: P. von Zabern, 1996.

Shearman 2003

Shearman, John. *Raphael in Early Modern Sources (1483–1602).* 2 vols. New Haven: Yale University Press, 2003.

Shell and Sironi 1992

Shell, Janice, and Grazioso Sironi. "Cecilia Gallerani: Leonardo's *Lady with an Ermine.*" *Artibus et historiae* 13, no. 25 (1992): 47–66.

Syson 1997

Syson, Luke. "Consorts, Mistresses and Exemplary Women: The Female Medallic Portrait in Fifteenth-Century Italy." In *The Sculpted Object 1400–1700*, edited by Stuart Currie and Peta Motture, 43–63. Brookfield, VT: Ashgate, 1997.

Syson 2008

Syson, Luke. "*Belle*: Picturing Beautiful Women." In *Art and Love in Renaissance Italy*, edited by Andrea Bayer, 246–54. New York: The Metropolitan Museum of Art, in association with Yale University Press, 2008. An exhibition catalogue.

Talvacchia 2007

Talvacchia, Bette. *Raphael.* New York: Phaidon, 2007.

Urbino 2009

Raffaello e Urbino. Edited by Lorenza Mocchi Onori. Milan: Electra, 2009. An exhibition catalogue.

Vaccaro 2013

Vaccaro, Mary. "True Beauties." *Apollo* 178, no. 615 (December 2013): 66–71.

Valone 2001

Valone, Carolyn. "Matrons and Motives: Why Women Built in Early Modern Rome." In *Beyond Isabella: Secular Women Patrons of Art in Renaissance Italy*, edited by Sheryl E. Reiss and David G. Wilkins, vol. 54, *Sixteenth Century Essays & Studies*, 317–35. Kirksville, MO: Truman State University Press, 2001.

Vasari ed. Barocchi and Bettarini 1966

Vasari, Giorgio. *Le vite de' più eccellenti pittori, scultori e architettori: Nelle redazioni del 1550 e 1558.* Vol. 4. Edited by Paola Barocchi and Rosanna Bettarini. Florence: Sansoni Editore, 1966.

Vasari ed. Milanesi (V–M)

Vasari, Giorgio. *Le opere di Giorgio Vasari.* Edited by Gaetano Milanesi. 9 vols. Florence: G. C. Sansoni, 1906. Facsimile edition published 1998 by Le Lettere.

Verstegen 2007

Verstegen, Ian, ed. *Patronage and Dynasty: The Rise of the della Rovere in Renaissance Italy.* Vol. 77, *Sixteenth-Century Essays & Studies.* Kirksville, MO: Truman State University Press, 2007.

Walter and Zapperi 2006

Walter, Ingeborg, and Roberto Zapperi. *Il ritratto dell'amata: Storie d'amore da Petrarca a Tiziano.* Rome: Donzelli, 2006.

Washington 2001

Virtue and Beauty: Leonardo's "Ginevra de' Benci" and Renaissance Portraits of Women. Edited by David Alan Brown. Washington, DC: National Gallery of Art, in association with Princeton University Press, 2001. An exhibition catalogue.

Weppelmann 2011

Weppelmann, Stefan. "Some Thoughts on Likeness in Italian Early Renaissance Portraits." In *The Renaissance Portrait: From Donatello to Bellini*, edited by Keith Christiansen and Stefan Weppelmann, 64–76. New York: The Metropolitan Museum of Art, in association with Yale University Press, 2011. An exhibition catalogue.

Williams 2012

Williams, Allyson Burgess. "Rewriting Lucrezia Borgia: Propriety, Magnificence, and Piety in Portraits of a Renaissance Duchess." In *Wives, Widows, Mistresses and Nuns in Early Modern Italy: Making the Invisible Visible Through Art and Patronage*, edited by Katherine McIver, 77–97. Burlington, VT: Ashgate, 2012.

Wolk-Simon 2008

Wolk-Simon, Linda. "'Rapture to the Greedy Eyes,' Profane Love in the Renaissance." In *Art and Love in Renaissance Italy*, edited by Andrea Bayer, 42–58. New York: The Metropolitan Museum of Art, in association with Yale University Press, 2008. An exhibition catalogue.

Woods-Marsden 2001

Woods-Marsden, Joanna. "Portrait of the Lady, 1430–1520." In *Virtue and Beauty: Leonardo's "Ginevra de' Benci" and Renaissance Portraits of Women*, edited by David Alan Brown, 63–88. Washington, DC: National Gallery of Art, in association with Princeton University Press, 2001. An exhibition catalogue.

Photography Credits

Index

Page numbers in **bold** indicate illustrations.

A

Alcmene 38
Aldobrandini
 family 12, 28, 51n4
 Ippolito *see* Clement VIII, Pope
 Margherita 54n46
 Olimpia 12, 47
Alexander VI, Pope 20, 22, 26, 52n18, 52n19, 52n20, 53n26
Alexander VII, Pope 52n21
Alighieri, Dante 33, 56n63
 Beatrice (from *The Divine Comedy*) 33, 56n63
Altoviti, Bindo 52n14
Aretino, Pietro 55n62
Avignon 56n2
 Church of Saint Claire 56n2

B

Barocci, Federico 19
Beatrix of Aragon 57n26
bella donna 30, 31, 52n14
Bellincioni, Bernardo 57n15
Bembo, Bernardo 35, 38
Bembo, Pietro 22, 31, 53n25
Benci, Ginevra de' 35, 38, 56n9
Benimbene, Camillo 29, 53n35
birthing tray (*desco da parto*) 42, **43**
Boccaccio, Giovanni 33
 Comedy of the Florentine Nymphs (Comedia della ninfe fiorentine) 56n64
Borghese
 Camillo *see* Paul V, Pope
 family 11, 12, 51n4
 Paolo 12
Borgia
 see Alexander VI, Pope

Cesare 20
family 20, 23, 26
Lucrezia 20, 22, 52n19, 52–53n24, 53n25, 53n26
Lock of hair 22, **22**
Botticelli
 Simonetta Vespucci 55n60
Bramante, Donato 55n58
Bronzino 54n42
Burchard, Johann 53n26

C

Cagnolo, Niccolò di, of Parma 52n24
Capponi, Lodovico 54n42
Carbognano
 Rocca Farnese 22–23, **24–25**, 53n30, 55n60
 Women with Unicorns **24–25**
Cardona-Anglesola, Doña Isabel de Requesens y Enriquez de 51n13, 52n14
Castiglione, Baldassare 28, 30, 55n62
 Book of the Courtier 30, 55n59
Catherine of Alexandria, Saint 12, 47, **48**, 52n24
Chigi, Fabio *see* Alexander VII, Pope
Clement VIII, Pope 12
Colonna, Marcantonio 53n35
Corvinus, Matthias 57n26
Cupid 43

D

Dish Depicting a Virgin and a Unicorn **42**, 57n26
Domenichino 53n27
Donati, Lucrezia 34, 56n9
Doni, Agnolo 15

E

ermine 38, 40, 41, 43, 57n16, 57n20
 symbolism of 38, 40, 41
Este, Ercole d' 57n19

F

Facchetti, Pietro 52n21
Farnese
 Alessandro *see* Paul III, Pope
 family 12, 22, 23, 28
 Federico 52n20
 Giulia 20, 22, 23, 26, 29, 30, 31, 44, 52n18, 53n24, 53n26, 53n27, 54n40, 55n58, 55n60
 heraldry 22, 23, 26, **26**, 31, 54n40
 Pier Luigi the Elder 22
 Ranuccio il Vecchio 22
 Ranuccio I 54n46
 see also Rome, Palazzo Farnese
Fiorentino, Adriano 55n56
Florence 12, 16, 20, 30, 35, 51n8, 54n49, 55n61
Fournival, Richard de 40
 Bestiaire d'amour 40, **41**
Francesca, Piero della 23

G

Gallerani, Cecilia 38, 41–42, 57n14, 57n15, 57n16, 57n18, 57n19
Ghirlandaio, Ridolfo 51n1
Girdle with Profiles of Half-Length Figures **28**
Gonzaga
 Cecilia 23
 Eleonora 53n35
 Elisabetta 29–30, 55n53, 55n56
Gozzadini, Ginevra d'Antonio Lupari 23

H

Helen of Troy 34
Hercules 38
Homer 57n18

I

Ischia 22
Isola Bisentina 53n28

tomb of Ranuccio Farnese il Vecchio 22, 53n28

J

Jerome, Saint 52n17
Joanna of Aragon 51n13
Julius II, Pope 23, 26, 29, 30, 31, 53n35, 55n54, 55n58
Juno 38
Jupiter 38

L

Laurana, Luciano
 Palazzo Ducale, Urbino, courtyard **19**
Leo X, Pope 52n20
Leonardo da Vinci 16, 23, 35, 38, 40, 41, 43, 51n10, 51n12, 56n9, 57n24
 Allegory of the Ermine 57n24
 A Study of Hands 56n9
 Lady with an Ermine 38, **39**, 40, 57n15, 57n18
 A Maiden and a Unicorn 35, **37**, 57n12
 Mona Lisa 15, **15**, 16, 51n10
 Portrait of Ginevra de' Benci 35, **36**, 38, 56n9
 Studies on the Life and Habits of Animals 41
Leoncini, Don Lando 53n36
Liberalis, Antoninus 57n18
Longhi, Luca 53n27

M

Maestro delle Storie del Pane 23
Manfredi, Astorgio 52n20
marriage belt 28, **28**, 54n47, 54n49
marriage jewelry 28, 29, 31, 54n49
marriage portraiture 29, 31, 44, 54n45, 54n48
Martini, Simone 34, 56n63
Medici
 family 31
 Giuliano de' 52n20

Lorenzo de' 34, 35, 38, 52n20
Memling, Hans 51n10
Meyer zur Capellen, Jürg 47
Michelangelo 31, 34
Mila, Adriana de 22, 29, 53n26, 55n51, 55n53
Milan 35
Montefeltro
 Federico da 23, 51n8
 Guidobaldo da 51n8, 54n39

N
Naples 51n13
 King of 57n15
 Viceroy of 51n13

O
Orsini
 family 23, 28
 Gian Giordano 30, 53n35
 heraldry 26, **26**, 31, 54n40, 54n43
 Orsino 20, 52n19, 55n53
 see also Vasanello, Castello Orsini
Ovid 38, 57n18
 Metamorphoses 38

P
Pamphili
 Camillo 12
 family 12
Paul III, Pope 20, 22, 23, 52n18, 52n19, 53n27, 54n37
Paul V, Pope 12
Pausanias 57n18
Perugia 12, 52n17
Pesaro 57n26
Petrarch 23, 30–31, 33–34, 35, 38, 40, 42, 43, 44, 53n34, 56n63, 56n1, 56n2, 56n5, 56n7
 Africa 56n5
 Canzoniere 31, 34, 35, 38, 40, 56n63, 56n7
 Laura 30, 31, 33, 34, 35, 38,

42, 43, 44, 45, 56n63, 56n1
 Trionfi 23
 Triumph of Chastity 23, 42, 53n34
Physiologus 40, 57n20
Pia, Emilia 29–30, 55n56
Pinturicchio 20, 52n24
Pisanello 23
Pollaiuolo 52n14
Portinari, Benedetto 51n10
Pucci, Lorenzo 52n19, 53n24

R
Raphael 11, 12, 30, 31, 33, 34, 35, 38, 40, 41, 42, 43, 44, 45, 51n1, 51n7, 51n10, 51n12, 51n13, 52n16, 52n17, 53n27, 54n43, 55n52, 55n53, 55n54, 55n58, 55n61, 55n62, 56n7
 La Muta 55n52
 Portrait of a Lady with a Unicorn **10** (detail), 11, 12, 14, 16, 19, 20, **21** (detail), **27** (detail), 28, 29, 30, 31, **32** (detail), 33, 34, 35, 38, 40, 42, 45, **46**, 47, **49** (x-radiograph detail), 51n4, 51n12, 52n17, 54n46, 55n49, 55n60, 56n67
 as Saint Catherine of Alexandria 12, 47, **48**
 overpainted dog 20, 47, **49**, 54n43
 Portrait of Maddalena Strozzi **14**, 15, 16, 51n12, 53n33
 Portrait of a Young Woman 16, **17**, **50**, 51n12
 Small Cowper Madonna 12, **13**, **18** (detail), 19, 52n16, 52n17
 Transfiguration 53n27
Riario, Raffaele, Cardinal 53n36

Ripa, Cesare 23
 Iconologia 23
Romano, Giulio 51n13
Rome 11, 22, 30, 51n7, 53n27, 54n40, 55n58, 55n61, 56n5
 Chapel of the Ascension, Santa Maria Church 54n40
 Chigi bank 29
 Museum of Castel Saint'Angelo 53n27
 Palazzo Farnese 53n27
Rovere, della
 family 23, 29, 53n35, 54n39
 Felice 30, 53n35
 Francesco Maria 53n35, 54n39
 Giovanna Feltria 12, 30, 51n8, 55n58
 Giovanni 55n58
 heraldry 26, **26**, 54n44
 Laura Orsini 20, 22, 23, 26, 28–29, 30–31, 34, 44, 45, 52n19, 52n20, 54n43, 54n44, 55n51, 55n53, 55n54, 55n58, 56n63
 Lucrezia 53n35
 Niccolò Franciotti 23, 29, 31, 44, 54n43, 55n54

S
Santi, Giovanni 19
Sellaio, Jacopo del 43, 53n34
 Triumph of Chastity **9** (detail), 43, **45**, 53n34
 Triumph of Love **44**
Sforza
 Battista 23
 Beatrice 38, 57n19
 Ludovico (L'Ermellino) 35, 38, 41, 42, 57n14, 57n15, 57n16, 57n19
Soderini, Piero 51n6
Strozzi
 Alessandra 54n49
 Maddalena 15, 53n33

T
Tebaldeo, Antonio 28, 54n44
Tolfa, Vittoria della 54n40
Tomaso, Apollonio di Giovanni di 42
 Triumph of Chastity 42, **43**
Tornabuoni, Ludovica 53n33
Trotti, Giacomo 57n19

U
unicorn 22, 23, 28, 35, 40, 41, 42, 43, 44, 53n27, 53n33, 54n43, 57n20
 symbolism of 23, 28, 40, 41, 42
Urbino 12, 16, 19, 20, 29, 30, 31, 51n7, 51n8, 52n16, 52n17, 54n39, 55n52
 Church of San Bernardino 12, 19, 51n8, 52n16
 Church of San Francesco 16, **18**, 20
 Palazzo Ducale **19**, 19, 52n16

V
Vaga, Perino del 53n29
Vasanello
 Castello Orsini 22, 23, **24–25**, 26, **26**, 53n30
Vasari, Giorgio 11, 20, 51n1, 51n8, 55n58
Vatican 20, 22, 23, 52n20, 52n24, 53n36
 Borgia apartments 20, 23, 52n24
 Camera Apostolica 52n20
 Sala dei Pontefici 53n36
Veneto, Bartolomeo 52n24
Verrocchio, Andrea del 34, 56n9
 Lady with a Bunch of Flowers 56n9
Viterbo 22
Viti, Timoteo 19

Z
Zeuxis 34

Lady with a Unicorn

A Bridal Portrait

ANNA COLIVA, DIRECTOR, GALLERIA BORGHESE

Raphael's *Portrait of a Lady with a Unicorn* (see plate 1) is a philological enigma: the identity of the sitter is unknown and the painting's inventorial history is uncertain.[1] It is listed as having been in the Aldobrandini collection in 1682, but there are significant uncertainties due to differences of size,[2] although the subject is described precisely as "a seated woman holding a unicorn." This description was made before the figure in the painting was transformed into Saint Catherine of Alexandria sometime prior to the 1760 inventory that could provide a *terminus post quem* for the transformation.[3] The identity change of the figure instantly became a cause for confusion in subsequent inventories, which were apt to confound it with Raphael's other *Saint Catherine* (National Gallery, London).

In 1854, for the first time, an anonymous description of the Borghese palace contains an attempt at identification: the painting is listed as "*Portrait of Maddalena Doni Fiorentina.*"[4] This description was handed down unchanged until Morelli's assertion, which set the contemporary hares running with his bold description, that this "young woman with plump cheeks and a rather vacant expression, is none other than Maddalena Strozzi, wife of the Florentine Angelo Doni, transformed into a saint."[5]

The unequivocal identification of *Maddalena Doni* as the portrait that only resurfaced in 1922 along with its pair, that of her spouse Agnolo, forming the diptych conserved in the Pitti,[6] put a definitive stop to the attempt at identification begun by Morelli, despite the fact that this would have provided many satisfactory answers. The singular beauty of the painting, and the acknowledgment that it must have been painted to celebrate a marriage, a fact about which all scholars agree, mean that it must have been a historically important commission relating to a specific occasion.

Thus, before finally shelving once and for all a question of identity that does not apply in the case of the Pitti portrait, I should like to explore an absolutely empirical strand of analysis by comparing the two portraits—*Lady with a Unicorn*, in the Galleria Borghese, and *Maddalena Doni*, in the Galleria Palatina di Palazzo Pitti, Florence (see fig. 2)—in terms of physiognomy. More than a similarity exists between the two, aside from differences largely perceptible at first glance, such as the color of the eyes and hair, and the solidity of the facial traits that in the Pitti portrait define a member of the wealthy early sixteenth-century Florentine bourgeoisie with extreme realism, unlike the sublimated evanescence of the *Lady with a Unicorn*.

The identical shape of the mouth, the chin, the lower part of the cheeks and their juxtaposition to the neck is undeniable; even the nose, which appears more delicate in the *Lady with a Unicorn* only because of the clarity and formal idealization with which the figure is suffused, matches precisely in terms of the broad nasal dorsum, its placement in relation to the forehead between eyes that are equally round, their expression somewhat "vacant," as noted by Morelli. Even the shape of the forehead corresponds perfectly in both figures.

That such a marked similarity of facial characteristics is not simply a product of formal idealization is proved by the fact that, in other Raphael portraits of women made around the same time, such as *Portrait of a Woman* (*La Gravida*, Galleria Palatina di Palazzo Pitti, Florence) or *Portrait of a Young Woman* (*La Muta*, Palazzo Ducale, Urbino), the physical characteristics are completely different. Were it not for the fact that the *Lady with a Unicorn* looks so angelically blonde, the Pitti portrait could well be a portrayal of her a few years later, more mature and prosperous.

Another element that links the portraits—again, at a superficial first glance—is that each woman wears an astonishingly similar ornament, stunning pendants without parallel in terms of ostentation or size in any of Raphael's other portraits. The *Lady with a Unicorn*'s pendant is actually the most concrete and earthly thing about this angel-like figure, pictured holding a mythical animal in an ephemeral landscape.

There are other clues and more possibilities, should one wish to take this hypothesis further.

The double portrait of the Doni husband and wife in the Pitti is generally agreed to be a marriage portrait—in other words, made to celebrate their wedding. However, it is thought likely to have been made slightly after the wedding of Agnolo and Maddalena, which took place on 31 January 1504.[7] The date of execution is generally put at between 1505 and 1506[8] or between 1506 and 1507,[9] while John Shearman dates it even later, to 1508.[10] Maddalena Doni in the Pitti portrait does indeed appear significantly older than fifteen, which was her age at the time of her

marriage, having been born to Giovanni and Lucrezia Strozzi in 1489.[11] This would perfectly accord with the age of the young woman pictured with the unicorn.

It was the custom in Florence to commission works of art, and especially portraits of the bride, to commemorate a wedding, and an important family, such as Agnolo Doni's, would have had no reason to dispense with tradition.[12] Moreover, Agnolo was a particularly active patron of the arts and had not only entrusted Morto da Feltre with extremely elaborate decorations for his bridal chamber—much emulated by all of Florence—but had also commissioned the famous tondo from Michelangelo.[13] My contention is that the portrait made of Maddalena Strozzi on the occasion of her marriage in 1504 is the one conserved in the Galleria Borghese and that only later, probably to mark the long-awaited birth of her first child, a daughter, in September 1507, or even that of her son Francesco, in November 1508, was the diptych in the Pitti executed.[14] *Maddalena Doni*'s rounded curves are more typical of a young woman around the age of twenty, body and self-importance both swollen by motherhood.

Another coincidence that weighs in favor of the identification of Maddalena Strozzi as the *Lady with a Unicorn* is that her family, descended from Marcello Strozzi, of the collateral branch of the famous Florentine dynasty, resided in the Gonfalone dell'Unicorno section of the district of Santa Maria Novella.[15] Employing a unicorn as a symbol of virginity was a perfectly legitimate device when portraying a woman engaged to be married, but was not as commonplace in the early Cinquecento as it had been in court circles during the late Gothic period. This attribute, the unicorn, now being unusual, thus became eponymous with the painting, as did the equally whimsical ermine in Leonardo's Cecilia Gallerani (*Lady with an Ermine*, see fig. 16). Dogs, symbols of fidelity, were a more typical bridal attribute, and Raphael had in fact originally painted a dog, over which was only later superimposed the extremely animate figure of the unicorn, as radiography has disclosed (see plate 3).[16] No reason for this modification to the painting has ever been determined. It may perhaps have stemmed from a subsequent desire to better denote the fact that the bride was a member of a family living in that particular area, and to confer on her name and surname something of a heraldic celebration of civic power.

The girl's hair is worn loose about her shoulders, as befits her youth, while the woman in the Doni portrait has her hair bound into a braid known as a *coazzone*, appropriate to her status as a married woman. This suggests that the painting was conceived for a woman who was already married, and not for a young girl who was merely betrothed. Last but not least, the pendant, which in each portrait features the same group of gemstones (the ruby denoting

strength, the emerald possessing thaumaturgical powers linked to chastity, the sapphire symbolizing purity, and the pearl, also an allusion to purity, traditionally given to brides), while conforming to bridal iconography, has its own powerful personality and visual impact. Each of the ornaments is "an amazing jewel" which, rather than merely serving as a symbolic attribute to reference the family to which the sitter belongs, provides a precise identity for her. It would make sense, for instance, if both ornaments were gifts from Agnolo, whose passion for jewels and collection of gemstones were well known.[17] The two irregular, pear-shaped pearls were extremely rare even then, and hugely valuable, and could not simply have been generic attributes.

We are therefore presented with a series of clues, which, however, neither individually nor as a group, constitute definitive proof that the subject of both paintings is Maddalena Strozzi. It is nevertheless possible that such proof, documentary perhaps, may yet emerge. A number of clues do, however, make for a strong possibility. For example, none of Raphael's other portraits of women contain jewelry that could be described, like either of these pendants, as a "prominent larger-than-life jewel";[18] even the unusual shape of the two pendants' settings is "conceptually" similar, one might say. They belong to the same category of extremely ostentatious taste, despite the regulations imposed in Florence by the sumptuary laws and by the laws of style in particular, as outstanding jewels of this kind had not yet been introduced into portraiture. The importance of the unicorn, which also figures, in the form of a gold mount, on the setting of the pendant worn by Maddalena Doni, clearly references the woman portrayed. In the Maddalena Doni portrait, which depicts a married woman, as evidenced by the iconography, the inclusion of the unicorn on the pendant was probably a heraldic reference to her person and to her family, the Strozzi of the Gonfalone dell'Unicorno, rather than an allusion to chastity.

However, the designation of this mythical creature in 1504–1505 as a guardian of purity was a reworking of an archaic symbol that had been almost entirely superseded by the symbolism of the dog. The unicorn is a grandiose reference to the courtly rituals of the previous century. Thus, in the Borghese portrait too, the symbology of virginity might have needed to be bolstered with a further, more direct indication, such as the heraldic reference to the subject's family. This could only have been the Strozzi family at the time of Raphael's stint in Florence, as the only other possibility, the Farnese family, had not yet made the fortune on which its future mythography would be built.

Given the implications of this hypothetical possibility, the Galleria Borghese's *Lady with a Unicorn* would date from 1504, or early 1505 at the latest, given that

there is not always an easily quantifiable lapse of time between the commissioning of a painting and its delivery.[19] This portrait would therefore have been executed during the period in which Raphael is documented as mostly having been at the court of Urbino. The *Lady with a Unicorn* is painted as a pure embodiment of light, stunning in its overall luminosity. The fragile, transparent material from which it is made is at serious odds with that of the artist's portraits executed in 1506–1507, to which comparisons have been ventured, regardless of the fact that the color of their strong and conflicting hues is powerfully applied onto large surfaces and not attenuated by luminosity.

The only works that might bear any sort of comparison are Raphael's small paintings for the court of Urbino, *An Allegory (Vision of a Knight)* (fig. 21) and, especially, *Saint George and the Dragon* (fig. 22), in which the horse's head is painted in exactly the same way as the unicorn's. Both works are constituted of the same material substance—the same pale palette and an analogous extremely smooth and exacting preparation of the board—as well as the same fine pictorial surface. Here the color and the light achieve plasticity and the figures emerge from within and then expand; the clarity that dominates in these paintings and becomes diffused like a sort of dreamlike substance has little in common with the tonal and material solidity with which, for example, the figures of the Doni spouses are imbued. The same choice of colors and handling is also found in the landscapes against which the dragon fights Saint George and the lady holds the unicorn, while in *Portrait of Maddalena Doni* there is a powerful sense of the aging process, as conveyed by the artist's *Deposition,* also in the Galleria Borghese, painted with the same density and color palette.

The elements that the Musée du Louvre *Saint George,* the Washington *Saint George* (fig. 23), *An Allegory (Vision of a Knight),* and the *Lady with a Unicorn* all have in common were nurtured by the sophisticated courtly atmosphere, pictorial preciousness, and refined choice of subject matter permeating the court of Urbino, as of 1503 particularly, and also during the period in which Raphael spent longer spells in Urbino and while he, Castiglione, and Bembo were all there in 1506.[20] These subjects—the unicorn, the dragon and Saint George, and the secular allegory, the only one Raphael ever painted, of the sleeping knight—are the only such instances in Raphael's oeuvre, and it is no accident that they suggested themselves. All these circumstances fueled the idealized, mythical figures, the rites and costumes of courtly chivalric literature, with its mythical animals, mediaeval bestiaries, and late Gothic miniatures. The deliberately heraldic courtly rituality is reflected in the calm faces of the two Saint Georges,[21] both totally devoid of expression. In these paintings Raphael has dispensed with his frequent natural

expressiveness, although this nevertheless survives in the preliminary drawings,[22] which show the figures open-mouthed and wearing more animated expressions.[23]

The *Lady* and the small paintings executed for the Montefeltro dynasty of Urbino constitute a one-off interlude of formal sophistication in Raphael's work, a far cry from his bourgeois Florentine portraits, which emanate a different "energetic will to live."[24] All these works date from 1504 and 1505, a period to which I believe the Borghese portrait should also be assigned.[25]

Equally, an environment so imbued with literary atmosphere could well have sparked the angel-like depiction of the subject immersed in the magical ambiance of the *Lady with a Unicorn*, which is totally at odds with the portrayed realism of *Maddalena Doni*, and with Leonardo's nuanced use of chiaroscuro. Nor is *Lady with a Unicorn* the only example of Raphael's idealized transformation of his subject. His portrait of a *Young Man with an Apple* in the Uffizi, identified as Francesco Maria della Rovere, heir to the dukedom of Urbino, though executed when the atmosphere of the court of Urbino was at its most rarified, around 1504—a short time prior to the *Lady with a Unicorn*, according to our hypothetical dating—displays a completely different appearance from that of Francesco Maria della Rovere, ethereally portrayed with long blond hair and angelic features, not once but twice in the frescoes of the Stanza della Segnatura.[26]

A comparison of the preliminary drawings for *Saint George*[27] (fig. 24) and for the *Lady with a Unicorn*[28] (see plate 4), both made in pen, confirms the formal and chronological proximity of the works. Like the paintings, the drawings document the working up of elements entirely drawn from Leonardo, which especially in the *Saint George* drawing are even more accentuated in terms of pictorial transposition, such as the tail of the horse—which does not appear in the painted version—its swishing movement cleverly capturing the Leonardesque swirling dynamic in the Uffizi drawing.

The drawing of the portrait of a young woman in the Musée du Louvre, closely linked to the *Lady with a Unicorn*, is considered to be the most obvious proof of Raphael's interest in Leonardo's portraiture. The pictorial representation generally recognized as the Galleria Borghese portrait differs from the drawing precisely in those elements that most characterize the individuality of the subject, such as the facial traits, the hairstyle that in the drawing more exactly reproduces that of the *Mona Lisa*, and the position of the hands, which in the painting has been altered to accommodate the attribute, the unicorn. Raphael's most successful attempt at capturing the singular, unquantifiable facial appearance of the *Mona Lisa* lies in the drawing of a *Portrait of a Girl* conserved in the Musée des Beaux-Arts, Lille (fig. 25).[29]

In Raphael, the individuality of the features, characterized by the full cheeks and chin, the broad nasal dorsum, and the round and slightly vacant eyes, serve to transform the model, i.e. the drawing, into a portrait of an actual person, as was the convention in mercantile and bourgeois Florence during the very early Cinquecento. Its translation into paint took place within an altogether different cultural ambiance, the exquisitely rarified court of Urbino, the luminosity of an enchanted and whimsical dimension taking on a plastic and chromatic form imbued with inner clarity and transparency, bathed in an unnatural light, a world away from Leonardo's atmospheric and immersive landscapes.

Notes

1 This essay is adapted from Rome 2006.

2 Note, however, that the measurements in the 1682 inventory tend to be approximate.

3 For the events surrounding the transformation of the figure into St. Catherine, see Marina Minozzi in Rome 2006, pp. 123–25.

4 *Descrizione dei Quadri e della Galleria Borghese*, 1854–1859, Galleria Borghese archives, n. 44.

5 Giovanni Morelli, *Italian Painters: Critical Studies of Their Works*, 2 vol. (London: John Murray, 1892–1893), p. 26.

6 Alessandro Cecchi, "Raffaello fra Firenze, Urbino e Perugia (1504–1508)," in *Raffaello a Firenze: Dipinti e disegni delle collezioni fiorentine*, edited by Caterina Marmugi (Florence: Electa, 1984), pp. 37–128. Alessandro Cecchi (p. 105) reconstructed the events surrounding the Doni portraits by means of Court of Florence documents. The paintings entered the collection of Leopold II, Grand Duke of Tuscany, in 1826. Serena Padovani, "I ritratti Doni: Raffaello e il suo 'eccentrico' amico, il Maestro di Serumido," *Paragone* 61 (May 2005): 3–26.

7 Alessandro Cecchi, "Agnolo e Maddalena Doni committenti di Raffaello," in *Studi su Raffaello: Atti del Congresso internazionale di studi, Urbino–Firenze, 6–14 aprile 1984*, by Micaela Sambuvvo Hamoud and Maria Letizia Strocchi (Urbino: Quattro Venti, 1987), vol. 1, pp. 429–39; Padovani 2005.

8 Konrad Oberhuber, *Raffaello* (Milan: Arnoldo Mondadori Editore S.p.A., 1982), p. 62; Ferino Pagden and Zancan 1989, p. 55; Meyer zur Cappellen 2001, pp. 296–297.

9 Cecchi 1984, p. 115.

10 Shearman 1996, p. 205.

11 Cecchi 1984, p. 112; Cecchi 1987, p. 432.

12 Padovani 2005, p. 5.

13 Cecchi 1987, p. 429.

14 *Ibid.*, p. 437.

15 *Ibid.*, p. 432.

16 The most exhaustive history of the painting remains that of Bon Valsassina 1984, pp. 20–28.

17 Cecchi 1984, p. 42 and n. 100.

18 London 2004, p. 174, n. 51.

19 Shearman 1996, p. 203.

20 David Alan Brown, "Saint George in Raphael's Washington Painting," in *Raphael Before Rome*, volume 17 of *Studies in the History of Art*, edited by James H. Beck (Washington, D.C.: National Gallery of Art, 1986), pp. 37–44. Brown (p. 43) believes that the culture at the court of Urbino was influenced by Castiglione, rather than vice versa.

21 Paris, Musée du Louvre, inv. 609 and Washington, National Gallery of Art, inv. 1937.1.26.

22 Florence, Uffizi, 529 E and 530 E; Oxford, Ashmolean, P II 44; Washington, National Gallery, B 33.667; Eckhart Knab, Erwin Mitsch, and Konrad Oberhuber, *Raphael: Die Zeichnungen* (Stuttgart: Urachhaus, 1983), n. 130, 126, 128, 129.

23 For a different interpretation, see Brown 1986, p.38.

24 Mina Gregori, "Raffaello fino a Firenze e oltre," in *Raffaello a Firenze: Dipinti e designi delle collezioni fiorentine*, edited by Caterina Marmugi (Florence: Electa, 1984), p. 31.

25 Oberhuber 1982, pp. 29–30; London 2004, p. 136.

26 Ferino Pagden and Zancan 1989, p. 43.

27 Florence, Galleria Degli Uffizi, Inv. 530 E; Knab, Mitsch, Oberhuber 1983, no. 126.

28 Paris, Musée du Louvre, Inv. 3882; Knab, Mitsch, Oberhuber 1983, no. 125.

29 Lille, Musée des Beaux-Arts, Inv. 469; Knab, Mitsch, Oberhuber 1983, no. 103.

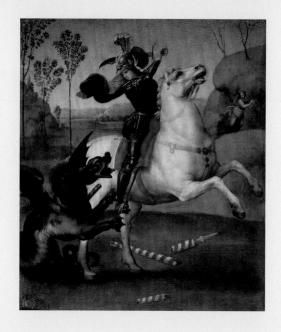

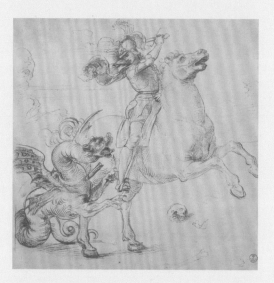

Fig. 21 (top left) Raphael (1483–1520)
An Allegory ("Vision of a Knight"), about 1504
oil on poplar, 6³/₄ × 6¹³/₁₆ in. (17.1 × 17.3 cm)
National Gallery, London, NG 213

Fig. 22 (top right) Raphael (1483–1520)
Saint George and the Dragon, 1505
oil on poplar, 12¹/₁₆ × 10⁹/₁₆ in. (30.7 × 26.8 cm)
Musée du Louvre, Paris, inv. 609

Fig. 23 (above left) Raphael (1483–1520)
Saint George and the Dragon, ca. 1506
oil on panel, 11¹/₄ × 8⁷/₁₆ in. (28.5 × 21.5 cm)
National Gallery of Art, Washington DC
Andrew W. Mellon Collection, 1937.1.26

Fig. 24 (above right) Raphael (1483–1520)
Saint George and the Dragon, about 1504–5
pen and brown ink over traces of black chalk
10⁷/₁₆ × 10¹/₂ in. (26.5 × 26.7 cm)
Galleria degli Uffizi, Florence, inv. 530 E

Fig. 25 (right)
Raphael (1483–1520)
*A Young Woman, half-
length*, about 1503–4
metalpoint on green
prepared paper
4¹⁵/₁₆ × 4 in.
(12.6 × 10.1 cm)
Musée des Beaux-Arts,
Lille, PL 469